WHAT PEOPLE ARE SAYING

DIGESTING RECIPES

Digesting Recipes switches beautifully between questions of genre, language, art and meaning. Susannah Worth thinks carefully and fruitfully about feminist arguments relating to art history and domesticity in particular, with sensitivity and great insight. Her sparkling prose is smooth and engaging, with fresh readings of some by-now classic feminist artworks as well as more recent and obscure pieces. Her focus is acute and laser-like, moving with ease between politics, history and aesthetics. The format of the piece – presented as courses of a meal – is ingenious and highly successful, allowing the inclusion of an interview, short critical entries, readings of specific artworks, an excellent cookbook bibliography, and so on.
Nina Power, author of *One-Dimensional Woman*

This is a wonderful book. As with the most seemingly casual of chefs, such acute intuition comes as the result of a great deal of work and a complete understanding of materials. The range of sources is expansive, and across many disciplines, and they are handled with confidence and an easy familiarity. As with many dishes, the simple things are the most difficult to achieve well, as there is no means of hiding bad ingredients or poor method. Neither is found here; indeed, good ideas, well presented are to be found on every page. This is a work that somehow manages to be both well done and rare.
Jeremy Millar, artist and writer

Food and hunger have long been recurrent themes in my own work. But I am not the only one! We are all hungry for guidance and recipes and instructions which make it easier for us to get

out of bed in the morning, easier for us to swallow the media's news, National Enquirer's fibs, easier for us to face our aging faces and IT-ed minds. Thankfully, Susannah Worth's book, *Digesting Recipes*, helps to get us to the truth of ART+LIFE.

Linda Mary Montano, performance artist and author of *Art in Everyday Life, Performance Artists Talking in the Eighties, Letters from Linda M. Montano, Mildred's Death* and *You Too Are A Performance Artist*

Susannah Worth sifts and pares the familiar genre of the recipe so that we might better appreciate how politically calorific this bearer of cultural codes really is. The manifold approach of *Digesting Recipes* to an apparently singular subject is invigorating, its visual art and literary leanings enriching. At a time when competitive leisure cooking, not to mention eating, saturates the television, the high street and the more prosaic channels of the brain, the book performs the important job of re-establishing critical and historical perspectives onto a quotidian authoritarian form.

Sally O'Reilly, writer of *The Body in Contemporary Art* (World of Art)

Digesting Recipes takes an off-beat and highly refreshing post-modern look at cookbooks as markers of cultural identity. Recipes, it makes clear, are far more than cooking directions. After reading this, I have a whole new appreciation for what recipes can tell us about the deeper meanings of modern society.

Marion Nestle, Professor of nutrition, food studies, and public health at New York University and author of *What to Eat*

Digesting Recipes

The Art of Culinary Notation

Digesting Recipes

The Art of Culinary Notation

Susannah Worth

Winchester, UK
Washington, USA

First published by Zero Books, 2015
Zero Books is an imprint of John Hunt Publishing Ltd., Laurel House, Station Approach,
Alresford, Hants, SO24 9JH, UK
office1@jhpbooks.net
www.johnhuntpublishing.com
www.zero-books.net

For distributor details and how to order please visit the 'Ordering' section on our website.

Text copyright: Susannah Worth 2014

ISBN: 978 1 78279 860 6
Library of Congress Control Number: 2014958370

A CIP catalogue record for this book is available from the British Library.

Design: Lee Nash

Printed and bound by CPI Group (UK) Ltd, Croydon, CR0 4YY, UK

We operate a distinctive and ethical publishing philosophy in all
areas of our business, from our global network of authors to
production and worldwide distribution.

Menu

A toast to my grandmothers: wonderful women, terrible cooks

Start first begin take put chop roughly chop finely chop prepare cut ready boil remove float drain singe sear slice trim snip tie cook overcook steam broil soak grill char chargrill fry deep-fry flash-fry pan-fry cover sprinkle splash reduce mix plunge knead stir thicken place preheat steep sieve wash add blanch whip chill put to decorate flavour braise season clean empty pour dry pour over skewer brown skim simmer purée cube dice peel peel off mash strain heat make surround press melt separate beat tip tap reserve set aside roll roll up roll out unroll cover drain bring to a boil shell put aside set aside pound wet moisten smoke singe roast poach bake bone crush grind layer oil grease flatten shake flip beat toast skin flour paint marinate wipe keep break scramble inject pluck stuff blend allow to cool snare salt baste sift form wrap divide drain drain off evaporate spread stick grate refrigerate double run a knife core scoop scrape substitute repeat mould unmould shape plait ice fold brush squeeze shave score whisk cool chill form halve scatter pipe crumble dot pulse pulp return warm dissolve cream rinse bring together work caramelise coat wrap measure sweat process open wait pull scald smear rub throw in pop tap empty whiz sew slash scale gut hang grab snip angle a blade crack start lift lower make sure test taste top dollop uncover draw away tilt transfer butter scramble combine allow to cool drizzle make a well quarter split tear rip pile toss griddle barbecue lay soften turn turn on turn up turn down turn over turn out turn off microwave defrost freeze rest dip break ladle swirl sauté flambé top and tail dry-roast pick invert shake reheat continue fill adjust stew blitz discard top up line bake blind press down pat dry par-boil shred spoon spoon over trickle blacken incorporate knock-up check shuck sizzle sit fillet pickle store thread twist up stone seed load seal liquidize prick glaze deglaze dress heap present plate up arrange stack accompany dust garnish finish serve

Introductions

'Let's open a dictionary to the words "Potential Literature". We find absolutely nothing. Annoying lacuna. What follows is intended, if not to impose a definition, at least to propose a few remarks, simple hors d'oeuvres meant to assuage the impatience of the starving multitudes until the arrival of the main dish.'
—François le Lionnais
La LiPo: Le Premiere Manifeste (1962)

'I want to be there in the kitchen with you; my words are merely my side of the conversation I imagine we might have.'
—Nigella Lawson
Nigella Bites (2001)

In 2001, Professor David Warburton, head of psychology at Reading University, announced the discovery of a new disorder which he termed Kitchen Performance Anxiety (KPA). Symptoms include mental block, distraction, sensitivity to noise and onlookers, as well as rapid heart rate, difficulty in breathing, nausea and headaches. He attributed the occurrence of Kitchen Performance Anxiety to the high standards set by Jamie Oliver's effortlessly sun-touched antipasti, Nigella Lawson's languorous linguine and Hugh Fearnley-Whittingstall's authentic rustic River Cottage rough-puff pastry pies. As these celebrities dance their way through immaculately choreographed renditions of finely rehearsed recipes, they are apparently leaving trails of nauseous mageirocophobes in their wake.

Food has always been of enough importance to warrant a host of associated anxieties: disordered eating, anorexia, bulimia, diet obsession and comfort eating; the display of wealth and good taste, social aspiration and 'keeping up with the Joneses'; as well

1

as religious and cultural rules, rituals and taboos. In *The Raw and the Cooked* (1964) Claude Lévi-Strauss related these two conditions of food (raw and cooked, or prepared) to states of nature and culture, and Mary Douglas explored food taboos in her influential book *Purity and Danger* (1966). Beyond the field of anthropology, scholarly interest in food, cooking and eating has developed within and across a range of disciplines, including history, sociology, philosophy, economics and more, all sharing concerns with the commonplace daily realities and the probing, wide-ranging insights that food studies can provide. In addition, there is a burgeoning strand of interest in the subject from a feminist perspective and in many ways food is always a feminist issue, or at least a gendered one.

Food can bring people together and create unity across cultural boundaries, but it is also a marker of contemporary society's stark disparities. Even on a news day when bombs have detonated at a marathon race in Boston; a 7.8 magnitude earthquake has struck the Iran-Pakistan border; and Margaret Thatcher's controversially extravagant funeral is less than 24 hours away, the 5th most viewed item on the *Guardian* website is about cake, and the 13th is about the relative merits of tinned food.[1] Food is in fashion, a middle-class obsession, dominating prime-time television, premium publishing and glossy weekend supplements. So-called 'post-feminist' blogs chant 'I am woman, hear me whisk.'[2] Meanwhile, unusual inventories are reported at protests against sexism and rape in Egypt: 'As the march sets off, the women hold knives high in the air, along with more novel weapons—sticks, wooden spoons, vegetable peelers, meat tenderisers—as if they'd marched en masse out of the kitchens of Cairo ready to tenderise the hell out of this patriarchal police state.'[3]

Digesting Recipes sits within this broad field of interest, focussing on the recipe as a metaphor, and as a form of writing. Examples come from published cookbooks and from visual art,

predominantly with a concern for feminist approaches. The nature of the recipe has been explored elsewhere in the context of magazines and literature, but far less so in art.[4] The case studies here are presented chronologically from post-war to now. Culinary and artistic examples are mostly drawn from the UK and USA, intentionally not respecting national boundaries so as to not falsify cultural ones, especially in the fields of art, food and feminism, where shared influences run deep.

The significance of cookbooks within western culture should not be underestimated. Their value as cultural documents and as works of literature has been well stated. Following the Gutenberg Bible in the 1450s, cookbooks were next on the printing block, with the *Boke of Kervynge* (Book of Carving) printed around 1508. Fast-forward to the 1980s and the persisting value of the cookbook is borne out by the *USENET Cookbook*. For this early experiment in pre-internet electronic publishing, Brian Reid has explained his rationale in choosing culinary content: 'I wanted to start a periodical that could be distributed electronically, that would use computers for every aspect of its production and distribution process, that would be on a topic of wide enough interest that I could get subscribers in as many countries as possible, and that was on a topic that I would find sufficiently interesting to be able to maintain interest in it long enough to get substantial experience. The obvious topic was cookery.'[5]

Abigail Dennis has written succinctly on the history of cookbooks 'From Apicius to Gastroporn' (2008), and Anne Willan takes the reader on an illustrated browse through her own personal collection from antiquity to the 19th century in *The Cookbook Library: Four Centuries of the Cooks, Writers, and Recipes That Made the Modern Cookbook* (2012). *The Cookbook Book* (2014) by Florian Böhm and Annahita Kamali is a celebration of cookbook design over the last 100 years. Nicola Humble's *Culinary Pleasures: Cookbooks and the Transformation of British Food* offers

incredibly rich detail on the subject, from Mrs Beeton to 'Now' (it was published in 2005), and Janet Theophano has addressed the subject of cookbooks with a North American focus, using cookbooks as primary resources allowing historical insight into the private sphere in *Eat My Words: Reading Women's Lives Through the Cookbooks They Wrote* (2002). Her approach is autobiographical, attempting to reconstruct these lives by reading in between the lines of ingredients and recipes. While broader cultural and social implications can be drawn from these readings, it can be limiting to narrow our view of these women's lives to the domestic sphere. Indeed any study in this area could be criticised for demarcating women's worlds along the same lines that feminism has fought to trample.

In 1989, Susan J Leonardi published an article in the Modern Language Association journal (*PMLA*) entitled 'Recipes for Reading: Summer Pasta, Lobster à la Riseholme, and Key Lime Pie'. In it she provides recipes for these dishes and then examines the act and implications of giving them, particularly in the context of an academic journal. Leonardi argues for a poetics of the recipe, using it as an example of embedded discourse and comparing its literal result to a kind of reproductive (and therefore gendered) function. Towards the end of the essay she confesses her anxiety to the reader: 'Do I erode my credibility with male academics in cooking, cookbooks and recipes?'[6] Presumably the question would also apply to female academics.

With an expanded approach to the recipe form, as viewed through the frame of artworks that can be read as critical and feminist, the subject addressed here is one of great breadth and reach. The recipe genre is an alluring field, not only because women cooks and writers have played an equal part in its production, but also for its lack of an exclusive (and exclusively male) canon of 'greats.' Women artists have frequently been attracted to video and performance for similar reasons and it is surely no coincidence that these mediums feature most often in

the essays that follow. The kitchen is a stage on which to follow the scripts which dictate men and women's models of behaviour, and in turn a platform from which to critique them.

The long and productive relationship between food and performance has been traced in 'Playing to the Senses: Food as a Performance Medium' (1999) by Barbara Kirshenblatt-Gimblett, who argues that the two converge at three conceptual junctures: firstly as an action or procedure to be executed; secondly as a behaviour indicative of, say, habit, custom, law or ritual; and thirdly as show or spectacle.[7] Kirshenblatt-Gimblett goes on to point out that: 'While we eat to satisfy hunger and nourish our bodies, some of the most radical effects occur precisely when food is dissociated from eating and eating from nourishment. Such dissociations produce eating disorders, religious experiences, culinary feats, sensory epiphanies, and art.'[8] The rejection of food—or at least the rejection of appetising or even edible food—is one strategy of opposition that features in the works discussed here. Often it is the familiarity and comfort associated with these quotidian, domestic subjects that makes their overhaul such a powerful statement.

John Langshaw Austin proposed the term 'performative' in a series of lectures given at Oxford (1951–54) and Harvard (1955) which came together in *How to Do Things with Words*. He presented his idea of performative utterances as 'speech acts'; in other words that by saying something, we do something. The most straightforward examples are phrases like 'I promise,' 'I nominate,' 'I sentence you,' or 'I pronounce you.' Austin's term was recently dusted down in Dorothea von Hantelmann's *How to Do Things with Art* (2010), in which the author attempted to rescue 'performative' from its slump towards 'performance-like,' and reinstate its value as meaning 'reality-producing.' In this sense, the term is of immense value when considering the recipe as a script for action and transformation.

If the recipe is a script or set of instructions to be acted upon

or performed, then it necessarily demands an active reader. This is an idea integral to the kind of reception theory which writer and Oulipo member Harry Mathews has proposed: 'The writer must take care to do no more than supply the reader with the materials and (as we often say nowadays) the space to create an experience. That is all the creating that takes places: of writer and reader, the reader is the only creator. This is how reading can be defined: an act of creation for which the writer provides the means.'[9] Whether in mind or matter, the dish will be completed by the reader. Perhaps for this reason, Mathews was drawn to the recipe on more than one occasion. In the verbosely titled 'Country Cooking from Central France: Roast Boned Rolled Stuffed Shoulder of Lamb (Farce Double)', first published in literary magazine *Antaeus*, no.29, circa 1980, he presents a fiction in the guise of a seductively grandiloquent recipe, stretching to over 5,000 words. The recipe includes an insistence upon marinading a whole lamb for five or six days, helpful asides such as that 'access to a cow is a blessing,' and seemingly endless specialist ingredients, including 'chaste, a fish peculiar to the mountain lakes of Auvergne.'[10] It was his writerly engagement with the recipe that caught the attention of Georges Perec and the Oulipo group, as Mathews explained in an interview in 2007: 'I had unwittingly written some purely Oulipian pieces. One of them was excruciatingly hard to do: I took two texts, Keats's *La Belle Dame Sans Merci* and a cauliflower recipe from a Julia Child cookbook. I made a list of the vocabularies in each piece and I rewrote the poem using the vocabulary of the recipe and vice versa... When I first visited the Oulipo, I told them about this. And what I had thought had been a shameful, secret habit was, to them, perfectly fine.'[11]

The idea of the recipe as a seed of potential is closely related to the interests of Oulipo, their name being a contraction of Ouvroir de Littérature Potentielle (Workshop of Potential Literature). When formed in 1960, the group stated its two-fold

intention: elaboration of new literary forms and analysis of existing experimental forms. This included non-intentional experiments and found texts, like the labels around Annette Messager's *Mon Livre de Cuisine* (see Chapter 3) which read like a concrete poem, or this glossary of carving terms from the 16th-century *Boke of Kervynge*:

Termes of a kerver.

Breke that dere
lesche the brawne
rere that goose
lyfte that swanne
sauce that capon
spoyle that henne
fruche that chekyn
unbrace that malarde
unlace that conye
dysmembre that heron
dysplaye that crane
dysfygure that pecocke
unioynt that bytture
untache that curlewe
alaye that fesande
wynge that partryche
wynge that quayle
mynce that plover
thye that pygyon
border that pasty
thye that woodcocke
thye all maner small byrdes
tymbre that fyre
tyere that egge
chynne that samon

strynge that lampraye
splatte that pyke
sauce that place
sauce that tenche
splaye that breme
syde that haddocke
tuske that berbell
culpon that troute
fyne that cheuen
traffene that ele
traunche that sturgyon
undertraunche that purpos
tayme that crabbe
barbe that lopster

Here endeth the goodly termes.

Dipping into the realm of poetry and fiction is just one strand of fantasy that the recipe form embodies; another is the aspirational dream of culinary and social success. Nicola Humble's *Culinary Pleasures* begins with Mrs Beeton, who she paints as a forerunner in the art of social ambition, and includes her suggested 'Bill of Fare for a Ball Supper for 60 Persons (for Winter)' and recipes for turtle, truffles and champagne: 'These are fantasy recipes, included not to be cooked but to be drooled over—and the fantasy is not strictly a culinary one, but rather a glittering vision of the luxuries awaiting those who make it to the top of the social ladder... The point of such rarefied inclusions is to give the upwardly mobile reader something to aspire to and to establish *Household Management* as an arbiter of elegant living.'[12]

A recipe can conjure idylls and utopias, and a recipe on the page or in the mind can be sustenance for the soul and the imagination. As Nell Heaton began in *The Complete Cook* (1947): 'Were it as easy to cook as to look in the book / And a wish were a dish

8

we could dine from our book.'[13] There is no greater testament to the power of the recipe on the page than cookbooks like the one composed by women imprisoned at the Terezín concentration camp (also known as Theresienstadt) during the Second World War, the period just preceding that addressed in the following essays. Of the 144,000 Jews deported to Terezín, only 19,000 were alive at the end of the war. On stolen scraps of paper, in the margins of propaganda leaflets, and even on the back of a photograph of Hitler, women would scribble remembered recipes: flaky strudel, cherry-plum dumplings, goulash with noodles, and gingerbread cookies.[14] Recalling, exchanging and arguing the finer points of a recipe was not only a distraction from extreme and prolonged hunger, but an act of defiance, an assertion of identity and community, and an escape into memory and hope.

Food has long been used in art, not merely to evoke abundance or beauty, but to critique, interrupt and intervene in fundamental aspects of life and society. In the endeavour to create and to change, the recipe's imperative tone and its instructive nature can make it a valuable tool as a call to action, or a dictating authority to be undermined. Transformation is bound up in the form of the recipe, both actually and metaphorically. Its status as banal and domestic allows it to speak suitably messily about whether to impose new realities or to challenge existing ones. It raises awkward questions from within the realm of flour and water, and conjures fantasies from the concrete and visceral medium of food.

Today, most published recipes begin with a tantalising photograph of the finished dish to capture the reader's attention and encourage them to follow, or at least to read on. Such an introduction—photographic or otherwise—could point to a recipe's vast potential and possible outcomes; at the same time it could imprint limitations in the mind of the reader. An Oulipian outlook would see, however, that a limitation need not be

reductive. Just as women artists have used their domestic skills and the materials at hand in order to make art, then formal constraints can create—perhaps counterintuitively—the conditions of freedom and play. Sophie Calle is one artist who provides herself with instructions; she describes a quality of restfulness and freedom in being trapped by the rules of a game, with no choice but to follow.[15]

This recipe 'digest' not only collects recipes, but attempts to break them down for 'use,' and perhaps provide some form of sustenance. Chronological but not comprehensive, the examples that follow attempt to draw out some interesting aspects of the recipe as used in art, and tends not to make conclusions, but rather offers a range of possible variations.

1

Hors d'oeuvre
The Recipe as Escape

The shared lives of Alice Babette Toklas and Gertrude Stein were suffused with food. It was a concern of such priority that in 1934 they considered reneging on a plan to spend time in the USA due to Stein's apprehensions regarding the cuisine in the country of her birth: 'tinned vegetable cocktails and tinned fruit salads, for example. Surely, said I, you weren't required to eat them,' Toklas recalled.[1] In 1910, when she went to live with Stein at 27 Rue de Fleurus, Paris, Toklas embraced new culinary complexities, preparing dinners à deux and frequently playing the good wife and hostess at parties. In turn, Stein nourished her imagination and encouraged her gastronomical experimentation. 'Cookbooks have always intrigued and seduced me,' Toklas once wrote. 'When I was still a dilettante in the kitchen they held my attention, even the dull ones, from cover to cover, the way crime and murder stories did Gertrude Stein.'[2] And perhaps while Stein was concocting 'Salad Dressing and an Artichoke', Toklas was busy rustling up a couple of Hearts of Artichokes à la Isman Bavaldy, a recipe from her own cookbook.

SALAD DRESSING AND AN ARTICHOKE.
Please pale hot, please cover rose, please acre in the red stranger, please butter all the beef-steak with regular feel faces.

SALAD DRESSING AND AN ARTICHOKE.
It was please it was please carriage cup in an ice-cream, in an ice-cream it was too bended bended with scissors and all this time. A whole is inside a part, part does go away, a hole is red

leaf. No choice was where there was and a second and a second.[3]

Stein's language gambols and gyres in loops and repeats, rejecting all traditions and expectations of linear narrative. It is gnomic and difficult, seeming to require specialist knowledge to unlock its secrets. Its experiment fits the modern model of exclusivity and 'high' art, and whether intentionally or not, it repelled many and alienated most; so to suggest comparison with something as banal as a recipe might seem hard to stomach. In fact, Stein's vocabulary is always ordinary and unemotional, and it is through context, attention and repetition that she renders it strange.

Both Stein and Toklas deal with the objects and words that construct our daily lives. *Tender Buttons*, from which the lines above are excerpted, is divided into three sections—Objects, Food, Rooms—each addressing the same domestic, everyday ingredients as Toklas's cookbook, and in the hands of both they are made extra-ordinary. Stein's work is full of humour and play, and her use of the present progressive tense gives a sense of being in the moment. This narrated action differs from the imperative voice of a recipe or Toklas's reminiscences that often surround the instructions, but it holds the same sense of presence and activity. Just as 'Hearts of Artichokes à la Isman Bavaldy' invites action, so 'Salad Dressing And An Artichoke' begs the active engagement of its reader.

This is the menu at a lunch party to which we were invited at a house whose mistress was a well-known French hostess and whose food was famous.

Aspic de Foie Gras
Salmon Sauce Hollandaise
Hare à la Royale

Hearts of Artichokes à la Isman Bavaldy
Pheasants Roasted with Truffles
Lobster à la Française
Singapore Ice Cream
Cheese
Berries and Fruit

This copious lunch was accompanied by appropriate and rare wines. There were at the table ten guests and six of the family. The fine linen and beautiful crystal, porcelains and silver were of the same quality as the menu.

Hearts of Artichokes à la Isman Bavaldy

Prepare 12 artichokes by cutting the leaves to within 2 inches of the heart. As each one is cut, put it into a recipient of cold water to which the juice of 1 lemon has been added. When all the artichokes are ready, shake them well to clean them in a quantity of running water. Put them at once in a large saucepan of furiously boiling water to which 1 teaspoon salt and 1/2 teaspoon cardamom seeds and the juice of 2 lemons have been added, and cover. There should be enough water to float the artichokes until they are tender, about 25 minutes according to size. As soon as a leaf can be removed easily, remove from flame, drain at once, and put into recipient of cold water and under running water. When water is tepid remove artichokes, drain, gently remove all leaves and the chokes. Trim around the hearts if necessary. The leaves can be scraped with a silver spoon and mixed with a little cream to be used in an omelette or under mirrored eggs. Boil 3 lbs. of small green asparagus tied in bundles in a covered saucepan of salted water. Cover and boil for about 15 minutes or until tender, but be careful not to overcook.

After soaking a sweetbread weighing about 1 lb. in cold water for 1 hour, boil in water to which 1/2 teaspoon salt, 2 shallots and 6 coriander seeds have been added. Boil covered for 20 minutes. Plunge into cold water and when cool enough, remove tubes and skin. Strain with potato masher through strainer. Put 2 tablespoons butter in frying pan, when the butter begins to bubble reduce flame. Put the sweetbreads in frying pan. Stir constantly until they are well mixed with butter. Sprinkle on them 2 tablespoons flour. Mix thoroughly. Then slowly add 2 cups dry champagne. Cook gently until this sauce becomes stiff.

Cut the asparagus within 2 inches of the tip. With the left hand hold an asparagus upright in the heart of an artichoke while a wall of the sauce is built around it with the right hand. The tips of the asparagus should show about 1/2 inch above the sauce. Cover the sauce with a thick coat of browned bread-crumbs. Pour 1 tablespoon butter over each asparagus tip and the breadcrumbs. Place the artichokes in a well-buttered fireproof dish and brown in preheated 425° oven for 1/4 hour.

It does not take as long as it sounds to prepare this dish. The lemon, champagne and coriander seeds give an ineffable flavour.[4]

Though Alice B Toklas had always wanted to write a cookbook, it wasn't complete until 1954, almost ten years after the Second World War had ended, and eight years after the death of Gertrude Stein. It was the cookbook of their life together. In the introduction, Toklas wrote: 'As cook to cook I must confide that this book with its mingling of recipe and reminiscence was put together during the first three months of an attack of pernicious jaundice. Partly, I suppose, it was written as an escape from the narrow diet and monotony of illness, and I daresay nostalgia for

old days and old ways.'[5]

Toklas relished cookbooks not simply for their helpful instructions, but for the narratives in which recipes are often embedded, as her own certainly were, and for a kind of novelistic escapism. Just as 'hors d'oeuvre' translates literally as 'outside the (main) work,' so recipe writing in the post-war years offered a glimpse of the foreign and the fantastical, while also elevating cooking beyond pure labour, to a realm of pleasure and pastime.

Post-war Britain endured far harsher food rationing than during the war years themselves. While in the USA food supplies had bounced back within a year, austerity continued in Britain until 1954, with restrictions even on basics like flour, bread and potatoes. Food was as grey and dusty as the rubble-strewn landscape, and without the motivation of patriotism or the inhibiting fear of war, women gathered together under the aegis of the Housewives' League to campaign against rationing and demand their daily loaf.

The war had given women a taste of work and inspired many to leave jobs in service to wealthy families, which in turn left wealthier women without cooks. More women than ever were cooking and, for many, the idea of setting up home and a sweet domestic life was a fantasy in itself: an escape from war-time hardships or long years spent working as servants. The advertising machine revved its engine, convincing housewives that a new fitted kitchen was the only way to achieve a happy, healthy home. Once in place, of course, the kitchen could be filled with myriad 'labour-saving' appliances. It was the rhetoric of efficiency, laced with the language of freedom. In reality it served only the consumerist economy. Though some women incorporated part-time work into their housewifely idyll, for many others life would soon tumble towards suburban seclusion, disconnectedness and depression, so that by the 1960s there was restlessness stirring in the kitchen.

Escape was sought in the domestic dream, but the recipes that guided these bright-eyed brides seemed to have the capacity to transport them even further into fantasy. Alice B Toklas compared her favourite recipes to the most compelling crime fiction, and Elizabeth David, who quoted copiously from literary works in her early books, acknowledged this imaginative appeal in the second edition of her *Mediterranean Food*:

> This book first appeared in 1950, when almost every essential ingredient of good cooking was either rationed or unobtainable. To produce the simplest meal consisting of even two or three genuine dishes required the utmost ingenuity and devotion. But even if people could not very often make the dishes here described, it was stimulating to think about them; to escape from the deadly boredom of queuing and the frustration of buying the weekly rations; to read about real food cooked with wine and olive oil, eggs, butter and cream, and dishes richly flavoured with onions, garlic, herbs, and brightly coloured Southern vegetables.[6]

Elizabeth David is often credited as single-handedly bringing such delicacies to the attention of the Brits, but in fact she was following in the footsteps of writers who had published in the inter-war years, such as Marcel Boulestin whose *Simple French Cooking* (1923) popularised French cuisine in English speaking countries, and Countess Morphy's *Recipes of All Nations* (1935) which very nearly lived up to its name. David's descriptions painted colourful pictures, evoking the sun-drenched lands where she had passed the war years, from Marseille to Sicily, Crete and Alexandria. She wrote with sensuality but also with the refined reserve of her class. She was good-looking, wealthy, intelligent; one of the new breed for whom cooking was a choice, an elegant, glamorous hobby. In the post-war years of shifting identities and new middle classes, Elizabeth David was the first

of many personalities who offered an image of the good life, away from the daily grind; a lifestyle to aspire to and a top-down model of good taste.

The war had brought international flavours to Europe and the USA, and though the latter had inspired a more casual culture in Britain, the great shifts that occurred within British society had led to much elbowing and social climbing. The new middle classes were learning to show off, and those who had known grander days asserted their position with strengthened snobbishness. Entertaining was a crucial tool in finding and proclaiming social standing and it lead to the kind of ostenta-tious culinary practices that Roland Barthes decried in 'Ornamental Cookery' written in the mid-1950s. In a critique of *Elle* magazine's food features, he notes that the emphasis on imagery implies a pompous appeal to sight ('a genteel sense') as opposed to the rougher experiences of touch, smell or taste. He criticised the magazine for presenting to its working-class readership, 'a cookery which is based on coatings and alibis,'[7] stating that the problem to be addressed was not one of how to decorate a partridge but rather how to afford one. He wrote: 'This is an openly dream-like cookery, as proved in fact by the photographs in *Elle*, which never show the dishes except from a high angle, as objects at once near and inaccessible, whose consumption can perfectly well be accomplished by simply looking.'[8]

Barthes's criticism can be applied to those cookery books which appealed to the mind and the imagination, rather than offering straightforwardly practical instruction; to those recipes which offered up a myth of artichokes, aioli and the happy housewife, in a time when women were marching for their right to a loaf of bread.

2

Salad
The Recipe as Event Score

In 1962, Fluxus artist Alison Knowles set down a proposition.

#2 Proposition
Make a salad.
(1962)

In a discussion years later she said: 'It was George Brecht who invented the event score, a recipe for action. Instead of recipes, I made "propositions" such as: *Make a Salad*, or *Child Art Piece*. These ideas stripped art down to the essentials of our everyday life.'[1] George Brecht seemed to corroborate this origin of the event score with his 1966 piece entitled *Event Score*, although bearing in mind the Fluxus flexible approach to authorship, this may be taken with a twist of irony:

Event Score
Arrange or discover an event.
Score and then realize it.

His *Time Table Event* (1961) is often cited as one of the earliest such works. More broadly, his scores swing from precise directions for playing a musical instrument…

Concert for Clarinet, Fluxversion 2
A clarinet is positioned upright on the floor. Performer with a fishing pole, sitting at a distance of a few feet should attempt to hook, lift and bring to his mouth the reed end of the clarinet.
(1962)

...to opaque monosyllables.

Two Durations
red
green
(1961)

And from the very beginning, some event scores dabbled in a curious kind of culinary notation.

Tea Event
preparing empty vessel
(1961)

Tea Event, Fluxversion 1
Distill tea in a still.
(1961)

Tied up in Alison Knowles's rejection of the 'recipe' label are all the commonly held assumptions about the contents of cookery books: the imperative verbs, prescriptive and prohibiting instructions, the hortatory ringing of reprimanding mothers and prim home economics teachers, and the authoritarian bravado of master chefs of the Escoffier ilk, all topped off with a judging glance and the anxiety of expectation. Knowles occasionally used the term 'proposition,' shifting closer to an air of suggestion, an offering, or even an Oulipo-esque constraint. Perhaps there is a contract at play in the proposal, a give and take, or gift and *receipt*, between text and reader, between artist, performer and audience. In fact, *Make a Salad* is not so far removed from the recipe. Take, for example, these characteristically brief instructions from a writer equally wary of the overly prescriptive recipe, Peg Bracken (from *The I Hate to Cook Book*, 1960):

Pretty Tomato Dressing

Just mix these things together:

3 whole onions, minced
3 sprigs parsley, chopped fine
2 large tomatoes, diced
1/4 cup Parmesan
1 teaspoon paprika
1 1/2 teaspoons salt
1 tablespoon vinegar
1 cup sour cream[2]

Or even...

Chutney Cream

Mix:

1 cup sour cream
1/2 cup chopped chutney
Juice of 1/2 lemon or lime

There.[3]

George Brecht and Alison Knowles were by no means the only artists to use the term 'score,' or 'event score.' Brecht's work emerged from the catalysing Experimental Composition classes held by John Cage at New York's The New School from 1956–59. Cage's work influenced artist George Maciunas, who was in many ways the leader and prime organiser of Fluxus and the festivals, or Fluxconcerts, first held in Wiesbaden, Germany in 1962. Most of Cage's students were artists with no prior musical training, and among them were Jackson Mac Low, Allan Kaprow,

2. Salad: The Recipe as Event Score

George Brecht, Dick Higgins, Al Hansen and Toshi Ichinayagi (who was married to Yoko Ono from 1956–63). Scores were to be minimal, with no set duration, and with much left to chance. In an essay titled 'Experimental Music', Cage wrote:

> And what is the purpose of writing music? One is, of course, not dealing with purposes but dealing with sounds. Or the answer must take the form of paradox: a purposeful purposeless or a purposeless play. This play, however, is an affirmation of life — not an attempt to bring order out of chaos nor to suggest improvements in creation, but simply a way of waking up to the very life we're living, which is so excellent once one gets one's mind and one's desires out of its way and lets it act of its own accord.[4]

Are chance and purposeless play any better embodied by the term 'score' than they might be by 'recipe'? As a verb the term is unequivocal (to score lines), competitive (to score points), and sexually aggressive (to score). An old score is a bitter grievance yet to be settled. Moreover, musical scores and notation, in the modern western form at least, are in fact highly codified and precise, with a complex lexicon of key signatures, time signatures, bars and beats, alongside an array of Italian directives: adagio, andante, allegro, fortissimo, forte, piano, pianissimo. The recipe also has conventions for notation, though far less formal: a title, ingredients list, instructions, with optional extras such as an introduction or narrative, diagrams or photographs.

What the term 'recipe' can offer is less notation and more annotation. The tips, amendments, successes and failures that append cookery books make up the diaristic crust that adds so much value to family heirlooms and junkshop finds. These scribbles dodge stains in worn margins, existing not only at the edge of pages, but also at the edge of language. In an essay published in 1979, Roland Barthes deliberated over his own daily

jottings, proposing the evocative potential of what he called 'interstices of notation.'[5] These are the things not written down, but rather the memories that are conjured and re-formed upon reading the notes on the page. Perhaps they bring to mind shifting sensations that would only be limited and caged by description, the kind of subjective experience and embodied knowledge that cooks rely on for seasoning, consistency and crunch.

Unlike a musical score, a recipe will usually strive for economy of language. The pared down simplicity that was so celebrated in those Experimental Composition classes created a style that seemed to say everything and nothing. In that respect, the event scores themselves are similar to titles, and often of comparable length. For the experienced cook, or the imaginative one, sometimes the title is instruction enough. The simpler the instruction, the greater the temptation to push and pull at its limits and possibilities.

The event score, like the recipe, is a restless form, open to endless repetition and re-enactment. Once published and made available, the recipe can be picked up and interpreted in infinite ways, with no single, definitive expression, no original, and no masterpiece. This idea seems to be borne out in the way Knowles dates her performances: while scores are given a date...

#2 Proposition
Make a salad.
(1962)

...performances are given a date of birth.

Make a Salad (1962–)

Make a Salad was first performed at the Institute of Contemporary Arts, London where Knowles recalls just cleaning a bit of lettuce in the bar and then serving it to maybe 30 people.[6] Those were the

days of the iceberg wedge, when in 1963, *McCall's Cook Book* claimed: 'Cut in wedges, it is a favorite of men, particularly those who like to pour blue-cheese dressing over it.'[7] The dressing might have been something like this from *The I Hate to Cook Book*:

Roquefort Dressing
Simply add crumbled Roquefort or bleu cheese to your classic vinegar-and-oil dressing. You can also buy good Roquefort dressing ready-made, at your friendly supermarket. Just look around.[8]

In conversation with Linda Montano, Knowles mentions achieving a cheese dressing at one memorable performance:

Make a Salad was first done in Denmark for 300 people... It turned out to be a very rebellious piece because it was performed at a concert funded by the music conservatory. The audience was really offended. We dragged in bushel basket bags of carrots and other vegetables to make a huge salad... Some of the audience stayed around for the hour of washing, chopping and tossing the ingredients in the barrel, which had been donated by the Crosse and Blackwell Marmalade Company. But they all came back mysteriously when the salad was finished. We even managed a cheese dressing. Some carrots were thrown back at us, but other than that the piece was a great success.[9]

Recent renditions have taken place in the Tate Modern Turbine Hall, London in 2008 and at New York's High Line in 2012. By this time, the salad had endured the prawn cocktail years and the emergence of pre-slicing and plastic wrapping, with the Marks & Spencer bagged salad appearing in the UK in 1986 and the Fresh Express salad-in-a-bag, new to the US market in 1989. The 1990s was the decade of 'continental' or 'speciality' leaves:

lollo rosso, batavia, romaine. The 2000s added a sprinkling of baby leaves, rocket, sprouts and shoots. For the High Line performance on 22 April 2012, ingredients included: 'enough locally-sourced escarole, romaine, frisée, carrots, cucumbers, onions, celery, and mushrooms for up to 1,000 people,' lightly finished with just oil and vinegar. The Tate Shots film made on the occasion of Knowles's participation in the Flux-Olympiad on 24 May 2008, introduces Fred the market trader: 'I'm Fred. I do all the supplies of fruits and vegetables to the Tate, and Alison's coming down today to pick some salads out, some tomatoes. Great thing about what we do here at the Borough Market is we get direct stuff in from the farmers, so, er... she loves all that, Alison! So, it'll be as fresh as possible when people go to eat it, when she chops it all up.'

The recipe seems to be a useful approach to reading event scores, and vice versa, but it does not necessarily follow that these event scores need to take food as their subject, or medium. However, the wide-ranging significance and nuanced meanings of food provide something that not only renders *Make a Salad* exemplary of the Fluxus moment, but also extends its reach and significance beyond the concerns of that movement.

John Cage's attention not just to sound, but to noise, was very much part of broader contemporary considerations of the everyday, and the ignored details of daily life. These lines of thinking were spun in the years following the Second World War and Theodor Adorno's famous proclamation that 'To write poetry after Auschwitz is barbaric.' It is a statement that can be understood as a cry for a new kind of art, unlike anything that preceded the war. After the horrors of an authoritarian vision for society, all illusions about long lost paradises and utopias had been shattered, and a renewed energy was focussed on everyday pleasures, freedoms and realities. Art should no longer provide a pretty distraction or substitute world. Cage's thinking was rooted in Zen Buddhism, Indian philosophy and the I Ching, philoso-

phies that found beauty in even the smallest things and took acceptance as their default position. More provocatively, Henri Lefebvre's *The Critique of Everyday Life* emerged in volumes in 1947, 1961 and 1981, proposing that to take a closer look at the everyday was inevitably synonymous with the desire to radically overhaul it.

As well as being perfectly indicative of everyday life, food allowed Alison Knowles to go beyond Cage's 'purposeless play,' transforming more than just leaves into a salad. Food and hospitality were valued as a way to create fellowship among the loft-living Fluxus community. Maciunas encouraged communal eating and food co-ops, rejecting the rocketing convenience foods market.

Just as working and eating together could break down hierarchies within the artist community, using food in performances allowed a questioning of power structures and ideas of mastery and authorship. Recipes exist without copyright, to be adapted and shared, and even published in other cooks' books, usually with acknowledgment and by way of admiration or homage. In relinquishing control of an artwork and moving away from the idea of art as a finished object, questions arose regarding what actually constituted the work, and who owned it. Many event scores were performed collectively, and many were written with another artist in mind, as though casting them in an acting role.

Food was a cheap and available medium, making it particularly enticing to women artists who bore the responsibility for maintaining a home. Fluxus artist Mieko Shiomi has said: 'We have a lot of obligations, and tasks, and many, many trivial things. Usually, our mind is occupied with these, like I'm a housewife, so I have a lot of things to do for my family. But when you look at things as an event, your mind is free from that kind of task. It's very free and released, and *yutakana* [enriching] moment.' It is a very honest and hopeful statement, but one with a disconcerting 'whistle-while-you-work' undercurrent. The use

of food in Knowles's *Make a Salad* should not be read as putting a positive spin on domestic labour. Taking art out of the gallery and the concert hall allowed greater freedom and accessibility to women artists who were unwelcome within the market-driven gallery system. By taking the recipe out of the kitchen, *Make a Salad* invited scrutiny and critique of hidden labour. By blurring the roles of performer and viewer, and producer and consumer, the piece not only brings the politics of food and domestic work out from the private sphere, but also presents a model of collective labour, with many hands and many knives at each performance.

Turning briefly from salad to tuna, in another work by Knowles called *The Identical Lunch*, the question of labour is raised again as the artist is situated, alongside fellow performers, as consumer. As the story goes, a friend who often joined Knowles for lunch at Riss restaurant, a local Chelsea diner, pointed out that she ate the same meal every day. The work developed from this, into the *Journal of the Identical Lunch*, which documented the participation of fellow artists and friends in their own enactments of Knowles's lunch. The score looked like this:

The Identical Lunch
A tunafish sandwich on wheat toast with lettuce and butter, no mayo, and a large glass of buttermilk or a cup of soup was and is eaten many days of each week at the same place and at about the same time.

The piece was performed in 2012 as part of MoMA's *Thing/Thought: Fluxus Editions, 1962–1978*. In this recent iteration, Knowles sat down each day at a table in MoMA's Café 2 to share *The Identical Lunch* with a small gathering of ticketed participants. According to *Village Voice* restaurant critic Tejal Rao, the meal was prepared by the 'Executive Chef' Lynn Bound:

And how does MoMA's sandwich compare to the old one at

Riss? 'It's better-quality bread,' says Knowles, 'and the tuna is quite extraordinary, certainly not from a can.' [...]

Bound prepares a light, modern tuna salad by cleaning and poaching the meat, then curing it gently. She tosses the fish with a mixture of olive oil, lemon zest, fennel, black olives, and capers. For the performance, Bound serves it on buttered wheat toast with a side of soup (the day I chat with her, it's carrot-parsnip) and a little cup of cold buttermilk.

While the recipe as event score allows the work to be shared or outsourced, in the hands of some artists labour is rejected entirely and the ultimate performance is in the imagination. Yoko Ono's *Tunafish Sandwich Piece* comes from her book of scores entitled *Grapefruit*.

TUNAFISH SANDWICH PIECE

Imagine one thousand suns in the
sky at the same time.
Let them shine for one hour.
Then, let them gradually melt
into the sky.
Make one tunafish sandwich and eat.

1964 spring

An artwork in its material self, the piece is most often presented as image rather than reproduced text and Ono has described these works as 'instruction painting,' emphasising the effect of the idea:

'Idea' is what the artist gives, like a stone thrown into the water for ripples to be made. Idea is the air or sun, anybody

can use it and fill themselves according to their own size and shape of his body... Instruction painting makes it possible to explore the invisible, the world beyond the existing concept of space and time. And sometimes later, the instructions themselves will disappear and be properly forgotten.

The association she makes between the idea and bodily sustenance resonates in *Tunafish Sandwich Piece*, which presents the connection with a playful wink: the sandwich filling to fill the body, and the idea to nourish the spirit. It is an immaculate conflation of scales, from a sky of one thousand suns to a single sandwich. In the event score, the recipe is emancipated from its role as trapping device and given new expansive potential.

Entrée
The Recipe as Mimicry

Turn to the POULET: POULE–COQ section of Annette Messager Collectionneuse's *Mon livre de cuisine* (My Cookbook) and there you will find a recipe, in French, snipped perhaps from a magazine. It is illustrated with a charming sketch of a chicken standing in a bed of decorative foliage, and in biro across the top, the title has been added by hand: POULET FARCI. The recipe card above it, for Coq à la Bière, is saturated with those unappetising mustard browns which immediately date food to around the 1970s. While the snippet is tainted by the residue of Sellotape, the card has been more respectfully taped at the corners, though slightly askew. If it had been done unthinkingly, it would seem imprecise.

POULET FARCI

Une grosse volaille à bouiller, un jarret de veau, un pied de veau, coupé, vin blanc, une demi-tasse de Madère, 350g de pâté de foie gras par 500g de volaille.

Mettez le poulet entier dans une grande marmite avec les os.

Recouvrez presque entièrement de quantités égales de consommé de poulet froid et de vin blanc. Laissez cuire doucement pendant au moins 30 minutes par livre. Une fois cuit, faites refroidir et farcissez le volaille avec le foie gras parfumé de Madère et éventuellement resalé. Mettez le poulet dans une cocotte avec le liquide dans lequel il a cuit et qui va se transformer en gelée au réfrigérateur. Ne recouvrez pas la

cocotte avant que le tout ne soit froid.

De petites pommes de terre bouillies et froides, roulées dans un peu d'huile d'olive et saupoudrées de ciboulette hachée. Assaisonnez selon votre goût.

Faites cuire les asperges à l'eau bouillante jusqu'a ce que vous puissiez transpercer les tiges avec un couteau. Etendez-les bien régulièrement dans une casserole peu profonde pour obtenir de meilleurs résultats. Servez-les glacées avec une sauce hollandaise froide (voir p. 223).[1]

In her early work Annette Messager assumed two identities and designated her work accordingly. Art objects were signed Annette Messager Artiste, while a series of around 60 Collection Albums were signed Annette Messager Collectionneuse. The division is satirical and prods at the hierarchy of these assumed identities. Made between 1972 and 1974, the albums include scrapbooks, notebooks and folders, combining hand-written notes, clippings, photographs, drawings and texts. They pose as an autobiographical output, with diaristic titles such as *My Wishes, Collection to Find My Best Signature, My Jealousies, My Daily Expenses over the Course of a Month, My Means of Protection* and *My Collection of Proverbs*. They appear to be the solitary snipping and glue-ings of a young woman. This fictional female obsessively constructs and copies instructional texts and how-to guides, such as *My Guide to Knitting* and *My Practical Life*, in which, alongside meticulous diagrams is a section on 'COOKING FOOD'.

In an annotated sketch, drawn around the same time, the artist divides the apartment of Annette Messager Artiste and Annette Messager Collectionneuse into two spaces of work: studio (*atelier*) and bedroom (*chambre*). Each space is reserved for a particular kind of work: bedroom work includes Arrangement

and Conservation of the Collections (*Rangement et Conservation des Collections*), under which fall the Collection Albums along with various other forms of documentation, such as catalogues. This is a private space of collecting, preserving and maintaining, not a space of artistic production. Just as the albums themselves store and conserve, so here things must be looked after and kept under control; only in the studio next door may wild creative passions be let loose. A bed takes up most of the floor space (presumably big enough for the two Annettes to share), while the Collection Albums are left to pile up on the floor.

This sketch is often used to explain the bisection of the Annette Messagers, but in fact there is also a space in between the two already mentioned that is rarely considered. Neat dichotomies must be muddied, and if you were to draw a line across the apartment at the precise half-way mark, then eating into the bedroom section would be the entrance, the bathroom and, largest of all, the kitchen. Meanwhile, the studio is quite distinct, existing uncluttered by life and its petty practicalities, its entrances and exits, ovens and cupboards, toilets and basins. On this, Messager wrote in 1976:

I wilfully spoke of areas that were previously neglected because considered of no interest.

Sewing, entertaining, cooking, etc, all of it places on the same level: feelings, events, menus, human interest stories, all presented with the same value, equal, without preference.

My condition forced me to be sweet, reserved, docile, I played by the rules to highlight this state where nothing was allowed except the pretense of being 'charming'.

'Women's work', neither finished, nor definitive....[2]

The scrappy section-markers around the edge of *My Cookbook* appear as follows. Out of context, they read like the axes of a graph, or a concrete poem in the tongue of gastronomie:

SALADES SOUPES OEUFS LEGUMES POISSON BOEUF

POULET
POULE—COQ

PORC
JAMBON—SAUCISSE

LAPIN

MOUTON
AGNEAU

VEAU

CANARD

DINDE

PIGEON

DESSERT
GATEAU—GLACE

SAUCES

This rendition of a kitchen diary bulges with cut-out-and-keep recipes from newspapers, scraps of paper covered in hand-written scrawl, and annotated recipe cards; those high colour, wipe-clean dependables that were a housewifely hit. The immaculate mimicry draws on the kind of household manuals that had been gathered and passed down for generations, or those published and marketed to new brides especially following the post-war construction of the contentedly consumerist housewife.

Out of context, *My Cookbook* could leave its viewers with only an appetite for Poulet Farci, but Messager's imitation is always the sincerest form of critique. She once explained this subtlety of approach in an interview with Robert Storr: 'France is an old country with stronger and weightier traditions than America... My story is therefore different [to American artists like Jenny Holzer and Barbara Kruger], and I deliberately play the game; no direct, frontal denunciations, I prefer underground channels, dark corners, meanders. I like to use all the traditional features of our life, of our culture and history.'[3] Earlier in the same interview she described her methods of working in the early 1970s: 'I mainly copied, recopied, repeated and re-repeated words, images, actions, stitches, all of which struck me as more pernicious than rebellion.'[4] Messager's words make the case for copying as critique, but the pernicious quality of repetition and reiteration could also be read in reference to domestic work, cooking and recording endless recipes.

In the context of the series, *My Cookbook* comes to represent its fictional author, as if it was a catalogue for her to display her wares, her repertoire of dishes, perhaps to potential suitors or visitors. She exists in a small, private, domestic world, seemingly lonely, intense and obsessive. These are her accomplishments and her materials for making. In fact, these are not records of making. The strangeness of this vast collection is the way it seems to be holding its breath, prepared but not yet able to actually fix, stitch, or cook. They could represent an escape into fantasy or, more likely, a safe retreat from life, from the studio, from the world. Of *My Practical Life*, Messager wrote in 1974: 'Annette Messager Practical Woman seems more serious, notes down everything that is important in her life, but in the end... she is perhaps the least reasonable because she doesn't make things but contents herself with copying notes she knows she will never use. This losing herself in practical details is her way of fleeing life.'[5] Is it so unreasonable to collect recipes but never

follow them? In an interview from 1995, Messager said: 'From the start I rejected "high" art materials because for me the making of paintings is too traditional and male. I wanted to find something more intimate, and to show the beauty of modest things. Is a cookbook more beautiful than a Rothko painting? I don't know, but it's a question I wanted to pose.'[6] Perhaps Annette Messager Collectionneuse is performing her own simultaneous strategy of critique in not obeying these domestic instructions.

4

Main course
The Recipe Re-formed

Like all good recipes, Martha Rosler's *Semiotics of the Kitchen* (1975) begins with its title, chalked up on a board as the day's menu. It is the first sign of many, and a neat inversion, white on black:

SEMI-
OTICS
of the
KITCHEN
© 75 M. ROSLER

Only the top half of her face is visible above the blackboard, eyes blinking, expressing all the warmth and welcome of a disgruntled dinner lady. Slowly the camera pans out. The scene is now set, and in a low-fi, black-and-white blur the signs of the kitchen are visible: oven, fridge, teapot, and books, of course. But there is no food in this kitchen, only food for thought, and Rosler employs various strategies to undermine the seeming complicity of presenting the feminist in the kitchen. In setting aside her substantial skills in using colour cameras and post-production editing, she rejects the gloss and glamour of television and advertising. In constructing a fake kitchen in a loft apartment, a stage full of kitchen symbols, she satirises the sets used in TV cookery shows, while simultaneously creating an uncanny remove from the kitchen.

At a drawn-out 45 seconds in, Rosler puts the board to one side and dons her protective layer, the apron. What follows is an inventory of equipment; an alphabetical glossary of kitchenalia.

Each item, from A to Z is presented to the viewer with a brief demonstration, recalling the on-screen likes of Julia Child and Fanny Cradock, or a department store sales demo. It is a parody she had used in *A Budding Gourmet* (1974) and went on to use again in *The East Is Red, The West Is Bending* (1977). However, in Rosler's kitchen there is no affection for the apron, no tenderness for the tenderiser. 'Bowl' gets a vigorous stir; 'Chopper' clangs inside a metal pan; 'Fork' jabs violently; 'Grater' scrapes sharply; 'Hamburger press' smacks together like an instrument of torture. 'Knife' is first caressed and later replaced on the table-top with all the care of a mother with a newborn baby, but in between these actions Rosler uses it to stab, stab, stab three times at the air, the final time pointing aggressively towards the viewer.

Equipment:

Apron
Bowl
Chopper
Dish
Egg beater
Fork
Grater
Hamburger press
Ice pick
Juicer
Knife
Ladle
Measuring implements
Nut cracker
Opener
Pan
Quart bottle
Rolling pin

Spoon
Tenderiser
U
V
W
X
Y
Z

At the awkward end of the alphabet, Rosler uses a large knife and fork as extensions of her arms, to act out an implicating 'U' (you?), 'V' (elbows together), 'W' (arms out, bent at the elbows), 'X' (arms crossed in defence). She then thrusts her arms up to the ceiling, throws her head back until it almost disappears, forming a Y with her whole body, a silent desperate heavenward cry: 'WHY?' After slashing a finalising 'Z' in the air in front of her with the Knife, she slowly folds her arms. Her shoulders and whole body look tense, her lips are pursed. She is motionless for a while, then flashes a shrug; a gesture of humorous resignation.

Rosler kindly, or not so kindly, provides a list of required tools, but Barbara T Smith allocates herself the task of offering a selection of ingredients. *Feed Me* was performed in 1973 as part of an event called All Night Sculptures which ran from sunset to sunrise at the Museum of Conceptual Art in San Francisco. The venue, more specifically, was the women's toilet, a large room with a toilet and a sink at one end. One at a time, visitors were invited into the room to interact with the artist. Each would find Smith sat naked, surrounded with items she deemed to provide potential for sensual connections. Playing on a loop from a tape machine in the corner, was a recording of the artist's voice saying, 'Feed me. Feed me.'

In a reversal of 'traditional' gender roles, the artist invited participants to work out what she wanted and provide her with sustenance and care: I'll put food on the table but you do the rest.

In discussions about the piece Smith emphasises that she was naked, not nude; that she was in control of the set-up, and that she was opening herself up to meaningful interactions, to sharing and gaining. Sixteen men and three women attended the performance, and Smith herself has acknowledged that this may have been attributable to the rumours circulating prior to the event that she intended to have sex with any and every male visitor to the show. In fact, she did have sex with three men that night and despite her insistence that she was in the position of power, another reading of this controversial piece is that she was offering her body in exchange for sustenance and attention.

When documentation for the piece was exhibited in *The Historical Box* at Hauser & Wirth, London in 2012, it consisted of two vintage prints, Smith's journal record of her interactions and five paperbacks used during the performance as well as a short descriptive text by the artist. One of the vintage prints shows her standing naked in the room. Her soft blonde hair hangs over her face as she looks down at something cradled in her hands. The sink is behind her, against a tiled wall and tatty brickwork. Some bottles are lined up along a bench. There is one rug on the floor and others covering a simple bed. The other photograph shows four people huddled around a door, presumably waiting their turn. These are some accounts of the ingredients that Smith placed in the room.

Ingredients and variations:

body oils,
perfume,
and flowers,
wine and
cheese,
bread,
books,

and tea
and marijuana[1]

bread
fruit
drinks
books to read
massage oils and perfumes
tea and coffee
beads and ornaments
marijuana etc.[2]

a mattress
rug pillows
and a heater
surrounded by things with which she could be fed such as
 body oils
perfume
food
wine
music
and marijuana[3]

It is a kind of retrospective recipe that Mary Kelly reveals in her *Post-Partum Document*. From 1973 to 1979, Kelly's work addressed the mother-child relationship, through her own experiences of raising her son. She focussed on three important moments in the growth of a child: the introduction of solid foods, starting to speak, starting school. *Documentation I*, the first of six parts in the series, included 22 stained nappy liners, each presented on white card in a Perspex frame, along with a typed list of the ingredients that Kelly had fed to her baby that day. It was a breakdown of what had been broken down and digested by her son; the recipe re-formed and the recipe re. formula.

Results:

JANUARY 5, 1974

09.00 HRS. 7 OZS. SMA
13.00 HRS. 4 OZS. SMA
17.00 HRS. 4 OZS. SMA
19.00 HRS. 3 OZS. ORANGE, 2 TSPS. CEREAL, 2 TSPS. APPLE
21.30 HRS. 8 1/2 OZS. SMA

TOTAL: 26 1/2 OZS. LIQUIDS, 4 TSPS. SOLIDS

FEBRUARY 28, 1974

09.30 HRS. 4 1/2 OZS. SMA, 3 TSPS. CEREAL, 3 TSPS. EGG YOLK
10.30 HRS. 2 OZS. ORANGE
12.30 HRS. 7 OZS. SMA, 4 TSPS. CARROT, 4 TSPS. BEEF
14.30 HRS. 3 OZS. ORANGE
17.30 HRS. 7 OZS. SMA, 3 TSPS. CEREAL, 12 TSPS. APRICOT
20.00 HRS. 2 1/2 OZS. RIBENA
21.00 HRS. 8 OZS. SMA

TOTAL: 34 OZS. LIQUIDS, 30 TSPS. SOLIDS

Rosler stages an attack on the kitchen and all its signifiers; Smith switches roles and demands to be fed and nurtured; Kelly rubs your face in motherhood's laborious dirty truth. In reformulating the conventions of a recipe, from the equipment, to the ingredients and the results, these three works represent strategies that are key to 1970s feminism. Each was produced or performed by women artists against a background of Women's Lib, the backlash against a patriarchal system that restricts women to the

private, domestic sphere, and demanded reconsideration of so-called women's work.

The question of how we value domestic labour has divided opinions within feminist thinking. In the 1960s, busy working mothers were advised to take a deep breath and get on with it, by recipe writers like Peg Bracken, who introduces the first chapter in her *I Hate to Cook Book* (1960) with this unnerving statement: 'Never doubt it, there's a long, long trail a-winding, when you hate to cook. And never compute the number of meals you have to cook and set before the shining little faces of your loved ones in the course of a lifetime. This only staggers the imagination and raises the blood pressure. The way to face the future is to take it as Alcoholics Anonymous does: one day at a time.'[4]

Later there were attempts to increase the visibility of such work, and calls for its celebration. Other voices, perhaps less well heard, instead insisted that the system should shift to allow women to achieve their full potential outside the home. In *The Sceptical Feminist* (1980) Janet Radcliffe Richards called for this: 'If women's work is private it is necessarily without status, and any promise to give it higher status must be vacuous. The only way status can appear is in publicly observable things.'[5] And this: 'domestic work cannot make the best use of the abilities of any highly able woman, and few achievements of any housewife are comparable with what a gifted woman could achieve outside... Women's work is of low status not only because of its privacy, but also because of the inherent mediocrity of much of the work.'[6]

As the hardship of the post-war years had eased and belts were loosened, the 1960s and 1970s saw a boom in cookbook publishing, catering to every possible niche interest, including those seeking to spend as little time in the kitchen as possible. Titles included the likes of *The Business Woman's Cookbook* (Elizabeth Craig, 1970) and *The Liberated Cook's Book* (Carol

Wright, 1975): 'The fastest meal is not so much breakfast, but the dinner party to be prepared after you arrive home from the office. Not only does the food have to be good and well presented, but so do you.'[7] They offered conciliatory humour and friendly tips for efficient weekday suppers, but never questioned that doing the cooking was just one more thing to be managed. Wright's statement above is not so far away from Mabel Claire's assertion in 1932, that: 'A cook should consult a mirror often. For what use is a decorative kitchen without a decorative woman in it!'[8]

It is the essential, everyday nature of the recipe, and the preparation and consumption of food more generally, that makes these interventions so powerful. As a form of writing rooted in the practicalities of daily existence, in some ways it was an easy target. For so many women artists the studio was (and is) the kitchen table, the nursery, or the bedroom. Barbara T Smith once acknowledged that in the absence of any theatrical training, it was the skills she had acquired as a housewife that allowed her to create her performances, which often involved the preparation of food and the ritual of sharing meals.[9] If the personal is political, you make art with the ephemera of your days, be it food, your own body, or dirty nappies.

While, on the one hand, the recipe is a mundane, quotidian form, it also presents an aspirational guide. This is what you want; this is what you need to do; take these step-by-steps to a better future. Along with 'lifestyle' rhetoric and celebrity chef culture, this aspirational aspect would later become a much more individualistic vision for fulfilling personal potential, but this was the heyday of second-wave feminism when hopes were high for a better, more equal society. If the recipe could be wrenched from the kitchen and kicked into shape, it could be given new purpose: Revolution à la Rosler.

Ripping up the recipe is not just an appropriation of the form, but also stages a critique of its illusive promises. In *Post-Partum Document*, Mary Kelly demands that attention be paid to the

work of a mother, alone and unpaid, and in this case balanced alongside the role of the artist. In summarising and representing an entire day through the waste products of her child, Kelly creates an image of a woman drained of any sense of self, as though she exists only by extension. Her role is to support, maintain, nurture, nourish, feed, clean, feed, clean, feed, clean. Her scientistic documentation makes invisible labour visible, and dishes the dirt on the cyclical, seemingly never-ending nature of childcare. Lasting satiety is impossible; the demands will never be completely met. The lists of ingredients that went into feeding her son are repetitive and boring; boring to type out, let alone to perform, no matter how sun-drenched and gurgly the SMA advertisements. Kelly's work derides the image of the happy housewife, refuting the lie that daily cooking is creative. To the inevitable critics of the nappy liners, framed and hung on the gallery wall, she seems to be saying 'if cooking is creative, here's what I made.'

The medium for all three artists here is used to reject the rarefied art object. The recipe is a form which, by its very nature, drives towards a result, the finished dish. Here it is re-formed to undermine a sense of satisfaction, completion or final product. *Semiotics of the Kitchen* is a freely available, intentionally bad-quality video; *Feed Me* was a one-off performance for a few eyes only, with only the scantest record; and *Post-Partum Document*, which comes closest to gallery object, perhaps deflects the illusion of valuable art object most strongly of all.

In employing the recipe, Rosler, Smith and Kelly undermine the form's prescriptive bark, proposing a critique of the kind of imperative language that dictates their actions. They interrupt the voice of patriarchal authority, and reject the recipe book as rule book, full of lists and strict instructions; the perfect soufflé and the looming Escoffier. But the site of the recipe is fraught with contestation and cannot be washed down the sink entirely. Feminist writer Sheila Rowbotham identified a major disjuncture

in the feminist movement as the 'distance between the discontents of daily life and images of alternative Utopian possibilities.'[10] Amid the day-to-day, the realms of reality and longed-for fantasy seem far removed, but meaningful change can be made by questioning the system from within, rather than taking radical leaps away from it. The recipe has the capacity to play an intermediary role in the space between art and life, theory and practice, fantasy and achievable reality.

Side dish
The Recipe as Reciprocity

a hard-boiled egg, dyed pink for women, blue for men;
a hand-made brown bread roll filled with Flora Margarine;
a small bag of crudités;
a small tub of aioli;
a piece of fruit.[1]

Traditionally, the recipe is a script for one actor. The tone of address always assumes a single cook, providing directions just for 'you,' perhaps alongside chummy tips and cosy winks: 'this one's a bit tricky, but if I can do it, so can you' or, 'don't worry, I'll take you through it step by step.' The most collaborative cookbooks are probably intended for when there is a child or two around to act as sous chef: 'get the little ones to make the icing stars while you give the mixture a good stir.' Bobby Baker's hard-boiled eggs (pink for women, blue for men) may well have been intended to transport her audience to childhood, to a state of being fed and nurtured, to playing together, but also to obeying commands.

Bobby Baker's work incorporates and performs scripted actions, taking on board Judith Butler's idea that gender is performative. She plays out banal domestic chores in the public realm. Taking cooking out of the kitchen not only raises questions around gender roles, but also issues of sustainability and food production, and of community. The menu above describes the food she prepared for *Packed Lunch* (1979), first performed at the Hayward Gallery in London. Eighty slides showing the creation of the lunch accompanied its consumption: 'They ate their meals watching a slide show with me "lecturing"

them on my skill, experience and consideration for their well-being in the preparation of these meals. I pointed out, for instance, the staggering beauty and strength of my hands as I crushed garlic into the mayonnaise.'[2]

Starkly contrasting with sleek cookbook recipes which present only the finished dish or a few glistening slices mid-preparation, this work emphasises the labour, from choosing ingredients through to washing dirty dishes. As Mierle Laderman Ukeles quips in a 2011 exhibition proposal accompanying her 1969 *Manifesto for Maintenance Art*: 'I live in the museum with my husband and baby. I do all the maintenance work including when the museum is open; I dust, clean, cook, feed visitors. Plus, Rirkrit, I also do the dishes.'[3] Baker also draws attention to her skill and technique, choosing foods which seem deceptively simple: hard-boiled egg preparation is, in fact, a divisive subject, and baking bread is a task that can fill the uninitiated with terror.

More than just a cookery show and a free lunch, *Packed Lunch* created a kind of contract for exchange, insisting on give-and-take instead of give-give-give. Bobby Baker cooked lunch and the audience ate, they learned about what they were eating and the care that went into making it. In return, they gave their attention, their gratitude and became involved in creating the piece. They played along, and engaged in all the questions the artwork raises, rather than just watching from the outside.

Hospitality is at the core of human life and has the power to define cultures. We talk of breaking bread together, and a companion is not just a friend, but in origin it is a 'bread fellow' (from Latin com- 'with' + panis 'bread'). It is not only drink that gets conversation flowing but also food. Baker's work exists within a framework that includes many intersecting meal-based projects, such as Rirkrit Tiravanija's *Untitled (Free)* (first performed 1992), Mary Ellen Carroll's *Itinerant Gastronomy* (1996–ongoing), Lee Mingwei's one-on-one meals in *The Dining Project* (1997–ongoing), Michael Rakowitz's *Enemy Kitchen*

(2003–ongoing) and Caroline Hobkinson's *Immersive Dining Experiences*.[4] *Cheesecakes*, a 2012 project by Scottish artist Merlyn Riggs, brought female professors at Aberdeen University together with women working as prostitutes in the same city, to make cheesecake, following a recipe provided by the artist, while discussing issues of self-esteem and self-value. Suzanne Lacy has used food in a similar way, in performance classes at the Woman's Building in Los Angeles. Lacy sees food 'as a bridge between private rituals and social issues' and 'a metaphor for nurturing each other.'[5] Even the abstracted ritual of coming together around a table has proved fruitful in other works like *The Crystal Quilt* (1987) and its recent iteration *Silver Action* (2013) performed at Tate Modern in London. Projects like these, and the criticism that surrounds them, raise innumerable questions around the efficacy and value of collaborative and participatory art, and the potentially transformative role of art in society.[6]

For the first ever performance of a later piece, *Kitchen Show* (1991), Bobby Baker invited the audience into her North London home for a hot drink and a Nice biscuit, which she prepared and served. At every performance, Baker enacts and narrates a 'Baker's dozen' of kitchen tasks, including peeling carrots and admiring a newly opened tub of margarine. 'Action No.3' in the series of demonstrations is 'how to throw a ripe pear against a distant wall in fits of intense rage':

No.3

When I get angry in my kitchen, I feel the need to do something violent in order to release the tension. I find that throwing something is better than hitting someone.

Once I tried throwing a wine bottle on the floor—but it made an awful dent. Another time I threw an old glass tumbler

carefully into the corner of the room but it took ages to clear up and could have been dangerous. When I hurled an electric typewriter on the floor it was very expensive to repair.

I think that the best throwing action is to take a ripe pear and hurl it against a cupboard door. It's a good idea to have a practice, just to make sure that you're going to get it right. I have a run-in of about 10 feet and I use an action similar to the one I tried to learn when I was young—that of bowling a cricket ball overarm. Underarm would be 'sissy' of course.

I hurl the pear at the opposite wall so that it explodes bam/splat and I SHOUT at the top of my voice just at the moment of hurling.

I choose a cupboard door to throw against because it's painted with vinyl silk and the pear washes off more easily than from a vinyl matt wall. When I clear up the mess, I check inside the cupboard for little bits of pear. I don't like to see them when they get all brown and dried on.[7]

Through its presentation as a recipe or self-help style directions for action, this script is full of humour because it strikes at something uniting and true. The show received rave reviews, went on an international tour, and inspired audiences: 'I was mobbed thereafter in the street with people saying they'd taken to hurling pears around and felt "Bloody marvellous, thank you, Bobby."'[8] It is a similar sentiment of connection and reassurance that Sylvia Plath once recorded in a journal entry:

25 February 1956

I was getting worried about becoming too happily stodgily practical: instead of studying Locke, for instance, or writing—

I go make an apple pie, or study The Joy of Cooking, reading it like a rare novel. Whoa, I said to myself. You will escape into domesticity & stifle yourself by falling headfirst into a bowl of cookie batter. And just now I pick up the blessed diary of Virginia Woolf which I bought with a battery of her novels Saturday with Ted. And she works off her depression over rejections from Harper's (no less!—and I can hardly believe that the Big Ones get rejected, too!) by cleaning out the kitchen. And cooks haddock & sausage. Bless her. I feel my life linked to her, somehow.[9]

The tradition of the community cookbook is long and rich, especially in the US, though the Women's Institute has made a fair contribution too, and the spiral-bound *Northumberland Federation of Women's Institutes Cook Book* (circa 1950) combines a host of fascinations from Advocat to Yule Cake. Bobby Baker herself contributed a limited edition print entitled *Displaying the Sunday Dinner* to *SPACE Cooks*, a community cookbook produced to raise funds for SPACE Studios in 2002. In this glorious photograph, Baker has one foot in an apple pie, the other in a dish of custard, a belt of carrots, a beef bikini top, a roast potato necklace with matching earrings, and a cabbage leaf headdress. The artwork's list of materials read as a recipe: 'roast beef, roast potatoes, carrots, savoy cabbage, apple pie and baked custard.'[10] Similarly, the 110 contributing artists listed at the back of the book are the human ingredients within the SPACE community. The recipe is a powerful metaphor for the potential alchemy at play in these new exchanges and unions facilitated by food.

6

First Entremet .
The Recipe as Criticism

This is an interview with art critic and cultural theorist Jeanne Randolph, focussing on the subject of her essay 'Mincemeat: A Recipe for Disaster', a work of criticism written about Canadian artist Sheila Ayearst. The essay was first published as the introduction to the exhibition catalogue for *Verge: Sheila Ayearst* at the Macdonald Stewart Art Centre in Guelph, Ontario in 1990. It was republished in Randolph's 1991 collection *Psychoanalysis & Synchronised Swimming and Other Writings on Art*. The piece is categorised in that collection under 'ficto-criticism,' which Randolph has defined most simply as 'a story that seems to refer to what the artwork refers to.'[1] Randolph's ficto-critical texts sit alongside the relevant work of art, rather than approximating, translating or acting solely as secondary response. Significantly, ficto-criticism opens doors and raises more questions than it answers, refusing single perspectives and authoritative judgements.

'Mincemeat' is a curious kind of recipe, with a handful of spurious food history thrown into the mixture. In Randolph's words: 'There exists of course no recipe the realisation of which does not permit additions or substitutions of ingredients to heighten or perturb either the nutritive or evocative power of the dish.'[2] And so, this interview is intended to sit beside the original recipe, as variation or annotation.[3] Segments from Randolph's original essay introduce each question.

Combine a quarter pound each of dried, candied, chopped citron, orange peel and lemon peel.
Combining ingredients and submitting them to culinary technique is a venture that emboldens the cook, for she savours the process of

accidents and cunning from which results the concoction that, when presented to the dinner guest, confounds the distinction between material and immaterial, between physical sensation and figurative effect.

How did you come to the idea of writing a piece of ficto-criticism 'in the style of' a recipe?

Sheila and I had been good friends for years so I knew I had complete latitude. Sheila and I talked about the paintings in her exhibition long before the opening. She emphasized the domestic images most, her summary of it being 'I should name the exhibition Bitter Homes & Gardens'. I responded enthusiastically to this ironic title. The exhibition's actual title, *Verge*, does evoke a potential for shocking change, but in a more intellectual way. Anyway there were plenty enough images and ideas in the paintings that could be included in the idea of domesticity.

Circumstances and happenstance were prominent when I was facing the deadline for Sheila's catalogue text. I would be in Boston the entire week prior to the deadline. I hadn't been procrastinating but I believed that one uncomplicated week away from my usual schedule guaranteed that writing would be a ready pleasure. I was in Boston to attend some kind of psycho-analytic conference, staying at The Copley Plaza downtown, a charmingly pretentious place, with décor as if it was still 1885.

I distinctly remember sitting on the floral-print bedspread in my room and realizing that I had forgotten to bring any books or articles with me, an unusual situation for travelling and for writing. The image of a recipe, as often happens with a so-called choice of rhetorical method, just happened in an instant as I was looking at the bedspread. In retrospect perhaps the floral design included apple blossoms, rose hips or maybe even fruits—so from fruit to jam to cooking to recipe is a plausible trajectory. The idea of composing a recipe liberated me from any reference to anyone else's thought. A recipe is found ordinarily in a domestic

kitchen. Sheila is an unabashed feminist, and at the time, 1989–90, there were certainly many artworks that addressed the consequences of gender; domesticity was being depicted and written and talked about. A recipe would clearly draw the art audience and the readers away from patriarchal history and its ramifications. Sheila would like that.

I found a bookstore not too far away from the hotel and scribbled the mincemeat recipe on a piece of paper to bring back to the hotel.

Two and a half quarts of apples, peeled and sliced.
"The tarter the apple the sharper the blade." So the saying goes. Many a child watching his grandmother at the table cutting away spirals of bright red appleskin, splashing white rows of appleflesh with lemon or dilute vinegar, upon hearing her murmur this maxim would shudder at its message—that insolence would bring swift punishment.

How did the recipe form help shape your writing?

As you know I favour writing that can be read between the lines. Mincemeat is allegorical; the changes the ingredients undergo could actually stand for something altogether different going through its own changes. I enjoy provoking ambivalence about the information offered by ficto-criticism; in this instance the reader can decide whether to be entertained by the lore and context of the ingredients or whether to be annoyed at the obvious contradictions (for example Jesus singing about castles in Spain, and generally various details that no one could possibly have known). In those days I was still very self-conscious that my writing should, when possible, deliberately enact my theory of 'the amenable object', e.g. reading it offered readers the opportunity to, as I say, commit acts of elaboration.

We have all experienced recipes as technical procedure and also experienced recipes as approximations open to invention.

Mincemeat was written with a questionable presumption: that probably the readers would take it for granted that a recipe is 'the one best way' to produce a particular dish. Yet this recipe is as much about the lore of the ingredients, the cook and her guests, as it is about culinary technique. The culinary technique implicates not only the ingredients but also the cook and her guests.

I wanted, as always, to undermine the credibility of the recipe, and the credibility of myself as author(ity). I wanted the ficto-critical piece to have a certain silliness verging on satire. I was in the mood to lie. Away from home I was definitely more playful. If such attitudes were brought to a recipe, then in some sense it would not be a proper recipe—just as in those days supposedly a feminist was not a proper woman.

If I am doing the cooking in my own home, however, I detest recipes. They take all the adventure out of concocting a dish. With a recipe of course there's leeway for substitutions or changing proportions of ingredients, but that's not enough leeway for me! I want to court failure: spills, setting off the smoke alarm, trembling just when adding a spice requires a steady hand, using a very sharp knife awkwardly, impulsively grabbing an unconventional ingredient etc.

Sprinkle salt and pepper over half a pound of chopped beef suet, mixing well with half a pound of broken nut meats.

The naturally sweet nuts such as pecan and cashew should be avoided, and walnut or another bitter type preferred. The bitterness of the walnut should evince a barely discernible gall.

Why mincemeat? It's a very old-fashioned kind of recipe.

Old-fashioned is unfamiliar, especially considering the transformation of food as a mass marketed product in the late 20th century: old-fashioned is not likely to imply fast food, quite the reverse. Mincemeat is definitely a 'heavy', fat-laden dish, and

thus more likely to cause a shudder in our weight-obsessed North American culture. The 'meat' in the title is a slight jab at the fashion for vegetarianism. Lastly it's a dessert, which is also unnerving to people who think sugar is unhealthy. 'Mincemeat' itself sounds vaguely violent, which might also jostle a reader out of their complacency. Compared to a commonplace dish I felt that old-fashioned would be more conducive to the 'ficto' aspects of a text.

> *One quart of sour cherries,*
> *preferably the St. John's variety, although it is rare and seldom grown in quantity for transport or commercial canning. It is best to have pitted the cherries well in advance and keep them on ice.*

There seems to be a lot at stake in paying attention to the recipe. Did you see this approach as a kind of recuperative exercise, raising the status of domestic work?
I definitely did not even consider whether using the recipe genre was recuperative. There is a degree of bathos to offering a recipe instead of a scholarly exposition (or journalistic enthusiasm), but I don't accept the premise upon which we could claim that a recipe (women's domestic work) is just as 'valid' as a scholarly exposition (men's work). Or that so-called women's work needs recuperating. To me there is an undercurrent of complacency when a socio-economic/political interpretation is confined to, reducible to, distribution of power. This might imply that our values are perfectly sound and somehow only access to privilege and power need tweaking. Are our values perfectly sound?

Yet to offer a recipe instead of a scholarly exposition might upset, maybe insult, expectations. My critique of scholarly expositions of artworks was/is that scholarly expositions are, as is any writing, a rhetorical method (one might say 'a genre' or 'a style'). There is nothing more inherently authentic about a scholarly text. There's a political, maybe even an ethical, choice

being made when one decides which rhetorical method one prefers (whether for pleasure or its instrumental potential). As Wittgenstein said (sort of), 'Show me how a person does something and I will show you what they are after'. What accrues to the person who chooses the scholarly rhetorical method: Legitimacy? Credibility? Proof of intelligence? Verification they belong to a special group? Showing how they enjoy esoteric and unusual pleasures? Even (as you imply) reassurance that they are male supremacists?

At first reading, however, the naughtiness of offering a recipe instead of a scholarly exposition, or even a seemingly plain-talking explanation of the artwork's meaning, is good fun. Just because something is good fun doesn't mean it doesn't, upon reflection, reveal important questions.

Stir one pound of raisins with three quarters of a pound of currants and one and a half pounds of sugar.
Some recipes for raisins are exceedingly ancient, and culinary legends with which they are linked usually allude to food deliberately poisoned. In the oldest concoctions the inclusion of raisins was advised in order that the bitterness of the lethal fraction be masked by the raisin's darkly sweet taste.

Do you see the form of the recipe as a kind of proposition?
Recipes enact a logic, which is a kind of proposition about cause and effect: do this, then do that, then do this, then do that and the consequence will be THIS. Mincemeat, to repeat myself, was an experiment to reveal how something (the recipe) with an apparent technical agenda can be reshaped into something (an allegory) that has meaning, e.g. associations, derivations, connotations, evocations, ideas, implications, vulnerability to interpretations. If I could do such a thing to a recipe with its agenda, then a viewer could do more than such a thing to an artwork, which might have not even have an agenda.

Add one half freshly grated nutmeg.
The medicinal, noxious and symbolic properties of spices are vastly recorded. The lore of the nutmeg itself abounds with precautions, parables and miracles, sometimes without certain distinction between the three.

Would it be fair to see the piece as a critique of criticism as much as of Sheila Ayearst's exhibition?

It seems that ficto-criticism generally acts as a critique of criticism. My intention was to offer a critique that takes a closer look at how criticism functions as a rhetorical method, how criticism implies a relationship between three parties (artwork, critic and audience).

Nevertheless I think the cook comes off as a serious, though mischievous, creative figure who could conjure wondrous effects through knowledge of materials; in other words as an artist whom I respect for doing the same thing. Sheila thought I was referring to her when I described the cook.

Maybe the reader would go back and forth between details in the ficto-criticism and details observed in the paintings. If the reader wanted to take the time, maybe the reader could test whether the text was relevant to the paintings after all. I had persuaded myself that many of the attitudes and practices of the cook corresponded to the experience of artists with sensitive audiences, as well as including experiences with helpless viewers and arrogant critics.

Mix one half teaspoon of freshly grated cinnamon, of mace, of cloves and of coriander seed into one pound of chopped ox heart.
Pour one pint of cider upon all the above ingredients mixed in a cauldron.
This is to be cooked gently for two hours. It is best to slip an asbestos pad between the pot and the flame, to prevent scorching, which

would mar the taste and texture. The asbestos device is all that remains of the cook's traditional vigilance over this delicacy.

The subtitle, *A Recipe for Disaster*, might suggest that a rigid step-by-step analysis could be a doomed endeavour (and towards the very end of the piece, it's stated that the demand for divulgence of every ingredient will be a dinner guest's undoing). If that is the intended suggestion of the subtitle, are you setting the piece up to fail? Or at least to enact a failure?

I always set up ficto-criticism to fail; to fail to dictate or persuade the reader/viewer what the definitive meaning and value of the artwork are. If it fails in this way the reader/viewer has a choice what to 'do' next: give up or start considering ficto-criticism differently. The reader just might say to themselves: Since it has failed to do this, what other kind of success could there be?

7

Second entremet
The Recipe as Critique

In an interview published in the feminist art journal *n.paradoxa*, artist Olga Chernysheva declared: 'I have booked myself a place in a feminist paradise!'[1] It was a statement fortified and enriched with irony. Born in Moscow in 1962, Olga Chernysheva was a child of the Soviet Union, which existed until 1991. Her earliest works date from this moment of dissolution and radical change, and focussed on *The Book of Tasty and Healthy Foods* (*Kniga o vkusnoi i zdorovoi pishche*), the Bible of Stalin-era kitchens, produced by the USSR's Ministry of Food and slippery Soviet statesman Anastas Mikoyan. It was published in a multitude of different editions between 1939 and 1952, largely due to continuously changing governmental attitudes and policies, with a total of around 8 million copies printed in those years.

Its ubiquity and success as a tool of propaganda must have made it an appealing target for critique. So too did its sludge aesthetic with colour plates as grungy as the plates of food: ponds of unidentified green slop, chunks of meat in brown juice, and dollops of jaundiced cabbage parcels, each depicted alongside its recently vacated tin, can, jar or packet, neatly positioned for full-frontal product placement. *The Book of Tasty and Healthy Foods* was, in fact, the book of packaged and prepared foods that were made in the USSR following rapid modernisation of the processed food industry. The intention was to educate people to buy and eat these products, which were presented alongside visions of abundance, fanciful scenes of plentiful sun-drenched harvest and happy head-scarved workers. In a scenario that parallels Elizabeth David's exotic recipes in post-war Britain, most of the foods in the book were not available to the vast

majority of people in the Soviet Union, and certainly not in the quantities necessary to follow these recipes.

While the original book stood in critical opposition to western capitalist society, Chernysheva's work adds another layer of critique, albeit a more subtle and nuanced one. In a series of oil paintings that imitate illustrations from the book, Chernysheva addressed post-Soviet reality at its most everyday level, with all the simple banality and infinite significance that food can muster. Her appropriation and reclamation of these images undermines the vision of an all-powerful totalitarian state, able to infiltrate lives from the top down. This cookbook and its recipes exist as a metaphor for the Soviet Union's step-by-step plan for society. In satirising the microcosm, Cherynsheva cuts right to the heart of the system, refusing the rhetoric of driving progress.

The Book of Tasty and Healthy Foods is to be taken on good authority. As it states in the introduction to the English translation: 'It was first envisioned as a scientific work, emphasising the importance of healthy nutrition. It was written by experienced chefs, doctors and prominent scientists.'[2] The didactic, hortative tone finds its parallel in the illustrations which position the reader at the eye-level of a child, at the height of the workbench. Nutritional facts, culinary science, menu plans, lists of required tableware, step-by-step instructions for a better pie, a better home, a better society:

Correct distribution of nutrients and selection of dishes during the day is one of the most important requirements of rational nutrition.

While selecting ingredients for breakfast, lunch, and dinner, you have to consider which particular foods and their quantities are required for different members of the family, depending on their age and occupation.

A person who leaves their home in the morning without having breakfast will quickly tire at work and will experience loss of energy far ahead of lunch. Overabundant lunch on the other hand will result in drowsiness and loss of productivity.

Main goal of setting up the table is comfort, neatness and pleasant look of the dinner or tea table. Here is a sample set of tableware for 6 people:

Deep Plates 6
Shallow Plates 6
Appetizer Plates 6
Dessert Plates 6
Plate for Herring 1
Salad Bowls 2
Soup Bowl 1
Sauceboat 1
Round Dish 1
Oval Dish 1
Dish for Bread 1
Broth Bowls with Saucers 6
Containers for pepper, mustard and vinegar 1
Decanter for Water 1
Decanter for Fruit Juice 1
Decanter for Vodka 1
Wine Glasses 6
Shot Glasses 6
Champagne Glasses 6
Knives, forks, dessert forks 6

The imprecision of Chernysheva's oil-paintings render her versions unique, personal and unrepeatable, not objective representations of a perfect product to be uniformly churned out. In contrast to the western technique of lifestyle selling, the first

person singular, the celebrity chef, these rectangular boxes trap within them the fragmented, disembodied torsos and working hands of anonymous, incomplete women. The copies emphasise the large, soft, white hands; doughy, as though their identity has fused with their labour. In the same interview in *n.paradoxa*, the artist states: 'People are full-fledged, they are valuable, they must not be functionally reduced to the thing advanced by advertising, or by (multinational) global values. It is precisely the fullness of their value as human beings that allows them to survive.'[3]

Chernysheva's critical strategy here is to copy. These creations were obviously not made by the anonymous, disembodied hands they depict, but in choosing to copy, Chernysheva does choose to reiterate. For all that it is and all that it represents, *The Book of Tasty and Healthy Foods* had its merits; it sold well, was considered practical and informative. And after all, it is surely preferable to criticise a book than to burn it and write another. In an interview with Robert Storr in 2009, Storr raises the 'Soviet ideology of remaking the world in the image of a more perfect society,' and this is Chernysheva's response: 'For me the idea of remaking the world is very attractive but I would prefer to look for the seeds of Utopia in the present.' For those who know that perfection is as unattainable as caviar in the USSR, utopias can begin with the present reality, and radical upheaval with a recipe.

8

Dessert
The Recipe as Immaterial Capital

200 Easy Cakes & Bakes (2013) has a recommended retail price of £4.99. Printed small, below the publisher and series title, is the author's name: Joanna Farrow. Nigella Lawson's *How To Be A Domestic Goddess: Baking and the Art of Comfort Cooking* (2000) has a recommended retail price of £18.99 (paperback), £25 (hardback); it too contains around 200 recipes. This is a question of value. Millions of recipes are now devoured on TV or in glossy TV tie-in books, from celebrity chefs (men) or cooks (women) in their fabulous fictional kitchens with lives, families and aprons to match. In this so-called 'post-feminist' landscape of cupcake housewives and finger-sucking indulgences for one, food has never been more aspirational. Infused in its recipes, the cookbook industry sells us an image of lifestyles we do not have and a taste of restaurants we cannot afford to eat in.

In the introduction to her chapter on chocolate, Nigella Lawson insists on quality: 'stock up on the best bars of chocolate you can find, such as Valrhona, and proper, cooked-earth-coloured cocoa. Look for brands containing a minimum of 70 per cent cocoa solids. When in doubt, or in need, phone the Chocolate Society (01423 322 230).'[1] A few pages later, alongside the *de rigueur* full-page, full-colour, oozing gastro-porn photograph, is this recipe for Chocolate-Coffee Volcano. It requires an array of expensive, specialist ingredients and equipment, conflated with a jet-set lifestyle that is even harder to achieve than café crème brulée.

Chocolate-Coffee Volcano

Despite a move towards chic simplification, sometimes we need a touch of vulgarity in our lives. This pudding certainly provides that. The idea came from a pudding I had at Spago, the LA restaurant, comprising chocolate Bundt cake stuffed with raspberries and topped with crème brulée. This is my version: a light chocolate cake baked in a Bundt mould — that's to say, a turban-shaped one with a hole in the middle — its hole, once the cake's turned out and dampened with liqueur, filled with chopped walnuts with a creamy coffee custard poured over; finally, imagine sugar sprinkled over and that sugar set alight so that you've got a hard, crackle-glazed top. And funnily enough, although it is very much in composition and appearance a swaggering pièce de résistance, it's easy to make. Just isolate the three separate tasks: the making of the cake, which is infant-school easy; the making of the custard, which is so eggy it scarcely takes 5 minutes; and the final torching to turn the coffee custard into café crème brulée. Then — pa-dah!

for the cake:
300g caster sugar
140g plain flour, preferably Italian 00
80g cocoa powder
2 teaspoons baking powder
1 teaspoon bicarbonate of soda
1/4 teaspoon salt
4 large eggs, separated, plus 2 more egg whites (from the yolks you need for the café crème)
125ml vegetable oil
125ml water
1 teaspoon vanilla extract
25cm Bundt tin, oiled

for the café crème:

225ml double cream

6 large egg yolks

3 tablespoons light muscovado sugar

1 tablespoon instant espresso powder

for the topping:

approximately 12 teaspoons (i.e. 4 tablespoons) Tia Maria or
 rum

125g chopped walnuts

4 tablespoons demerara sugar

chef's kitchen blowtorch[2]

In an article entitled 'Why There's More to Cookbooks Than Recipes', Rachel Cooke once wrote: 'We buy them by the dozen, and we read them, many of us, in bed and elsewhere, devouring every page as hungrily as if they were novels. But how many do we really use? Not many, is my guess.'[3] The novel seems an apt comparison; Cooke goes on to mention the fine writing, and social and cultural history contained in cookbooks, but moreover that they offer her some kind of imaginary indulgence: 'it isn't about cooking. I like eating, and reading about food is the next best thing to eating it, with the advantage that it's less fattening. Like most women, I also have an active fantasy life: House & Garden plays a part in this, and so do cookery books.' The recipe provides the essence of good food, the idea of delicious; but like the fresh-bread-odour pumped out at supermarket bakeries, the likely result is a quick grab of a plastic-wrapped long-life pastry, or at the other end of the weighing scale, the over-ambitious purchase of a KitchenAid® Artisan® Stand Mixer, yours for around £400.

It seems we have bought into the lifestyle myth but, for a multitude of reasons, we are spending far less time in the kitchen and more money than ever on cookbooks: in the UK, £87 million

in 2011 compared to around £67 million in 2006.[4] Meanwhile 5.29 million people watched 2013's *MasterChef* final, and 7.9 million watched the opening episode of the 2014 series of *The Great British Bake Off*. We watch Jamie Oliver scooter about for fresh-from-the-market quality, listen to Rachael Ray wax lyrical over 'EVOO' (extra virgin olive oil), and experience vicariously the fresh flavours of the globe courtesy of Yotam Ottolenghi, but what we actually put in our mouths tells a different story. According to the UK Department for Environment, Food and Rural Affairs, the lowest 10 per cent of households by income reduced purchases of fruit and vegetables by 20 per cent between 2007 and 2010, consumption of 5-A-DAY (five portions of fruit and vegetables) is declining faster for women, with 15 per cent fewer achieving 5-A-DAY in 2010 than in 2006; and between 2009 and 2010, there was a 33 per cent increase in children in England who included no fruit and vegetables in their diet.[5] According to the US Department of Agriculture, 43.1 per cent of all food expenditure in 2012 was on food prepared outside the home, compared with 25.9 per cent in 1970, with fast food being the dominant source of that food. In fact, these are the ingredients that compose some of the foods we actually eat:

Sainsbury's Belgian chocolate éclairs
Our ingredients
Sweetened Whipping Cream (40%); Choux Pastry Éclair; Belgian Chocolate Fondant (24%).
Sweetened Whipping Cream contains: Whipping Cream*, Skimmed Milk*, Dextrose, Stabilisers: Tetrasodium Diphosphate, Sodium Alginate.
Choux Pastry Éclair contains: Pasteurised Free Range Egg, Wheat Flour, Rapeseed Oil, Unsalted Butter*, Salt.
Belgian Chocolate Fondant contains: Icing Sugar, Belgian Milk Chocolate (29%) (Granulated Sugar, Whole Milk Powder*, Cocoa Butter, Cocoa Mass, Emulsifier: Soya

Lecithin; Flavouring), Belgian Dark Chocolate (13%)
(Cocoa Mass, Granulated Sugar, Emulsifier: Soya Lecithin;
Flavouring), Water, Granulated Sugar, Dried Glucose
Syrup, Palm Oil. *From Cows' Milk.

or

Cadbury's Shortcake biscuits
Ingredients: Wheat Flour, Milk Chocolate (24%) (Sugar, Cocoa
Butter, Cocoa Mass, Dried skimmed milk, Milk fat, Dried
whey, Emulsifiers (soya lecithin, E476)) Vegetable Fat,
Sugar, Dried Whey, Raising agents (Sodium Bicarbonate,
Ammonium Bicarbonate), Salt, Flavouring.

E476, as in the Cadbury's recipe above, is actually polyglycerol
polyricinoleate. Just as the biscuits are covered in chocolate, so
the chemical additives are reassuringly wrapped in the language
of Health & Safety. Food labelling began in around 1958 when the
US FDA (Food and Drug Administration) enacted the Food
Additives Amendment, requiring safety tests and declaration of
all additives in food products. Labels as we recognise them today
emerged with the US Nutrition Labelling and Education Act 1990
and the UK's Food Labelling Regulations 1996. Under the guise of
a paternalistic state 'caring' for its citizens, these regulations are
the result of a balancing act between consumer demands and
commercial interests, where commercial interests rule.

These lists of encoded ingredients are the recipes for the age
of intellectual property. They actually reveal very little about how
the product was made, and certainly are not intended to be
'followed.' Books like *E for Additives* by Maurice Hanssen (1987)
enable you to 'crack the E-number code... so that you can see
exactly what has been added, where it comes from, why it has
been added, what it does to the food and—if anything—what it
might do to you.' With connotations of a burgeoning knowledge

economy, the implication is that access to this information is restricted. Extra knowledge is required to decode these lists, making the capacities of the person choosing or preparing the food more relevant.

Martha Rosler's *Romances of the Meal* is, in part, an attempt to discover and present the 'truth' about industrial food production, which the artist does using information easily accessible to anyone online. The work took place as an installation and performance as part of *Laboratorium*, an exhibition curated by Hans Ulrich Obrist in Antwerp in 1999. Obrist and Barbara Vanderlinden introduce *Romances of the Meal* as follows: 'Rosler investigates the industrial kitchen as a site of food production and as a metaphor for the channeling of creativity into things that are normalized, naturalized, and regularized and whose creations are intended to be consumed rather than celebrated. A factory of productivity as opposed to the craftsmanship and culture of the domestic kitchen in which women are expected to make fabulous food.'[6] Although the kitchen has often been seen by artists as a site for experimentation, the curators' assumptions regarding the creativity and celebration of domestic cooking seem to start off on the wrong foot, as Rosler would surely argue that the daily grind of 'women's work' is neither creative nor celebrated. It is a problem tied up in this statement by that stalwart of 'cheeky' sexism Jamie Oliver: 'My wife is a hands-on parent and that's a tough job. But the thing I'll never get is why my wife, why lots of wives, are always trying to prove that their job is just as hard as the man's job. Men don't need constant reinforcement about how brilliant they are. We just kind of crack on. But the girls do like to be constantly reminded how brilliant they are.'[7]

Documentation of *Romances of the Meal* is sparse, with no evocative photographs of cooking or food. The extensive catalogue text is the lasting result, including industrial-scale recipes that are often quite repulsive. There are clear parallels to a text piece written by the artist in 1975, called *Kitchen Economics:*

The Wonder of (White) Bread, a satirical tale of an all-American 'Granma' explaining the beauty of bread, incorporating an exposé of mass manufacturing. There is no nurturing nor nutrition here, just as there was none in *Semiotics of the Kitchen* (1975),[8] none at Judy Chicago's *The Dinner Party* (1974–79), none at Susan Frazier, Vicki Hodgetts and Robin Weltsch's *Nurturant Kitchen* in *Womanhouse* (1972).

For 24 dense pages, including three for endnotes alone, Rosler presents reams of information on the history of coffee. The average jar of instant coffee bears no information on ingredients or manufacturing methods, as though it were a pure 'natural' ingredient, fresh from the earth, but the extent of Rosler's information overload is testament to the true complexities of such processed foods. The chronology develops from a goat herder's discovery 'in Yemen or maybe Ethiopia' to JS Bach's Coffee Cantata and onto 'The Injustice of the Coffee Business'. There are extensive instructions for brewing the perfect cup of coffee, a discussion of coffee's changing social standing, and information on stages of processing.

Chocolate, Coca-Cola and caffeine are also given the investigatory treatment, with an increasingly scientistic approach provided by a punctuating series of molecular diagrams of caffeine, theobromine and theophylline and a smattering of tabulated data on subjects such as caffeine content in various coffee beans and blends. Rosler continues with the origins of our current romance with fine cooking, and addresses the subject of biotechnology and genetic engineering, experiments for which, she states, are 'controlled by such multinational chemical, pharmaceutical, and agrochemical companies as Monsanto, Novartis... SmithKline Beecham, Du Pont, Eli Lilly, Rohm and Haas, Upjohn, Merck, Dow Chemical, Synthélabo, and AgrEvo'.[9]

There are pages and pages of the history of Coca-Cola, flecked with carbonated frothy facts of dubious origin. Then comes a proposed 'experiment' to create homemade replica Coca-Cola.

The real recipe is, famously, a trade secret. Search online for any food brand name along with the word 'recipe' and many will return helpful suggestions for ways to use their product in a dish, from Hovis's multitude of 'ideas' for things to put on a piece of toast, to Cadbury's take on a chocolate cake. None will offer up an insight into the manufacture of their own product: that immaterial nugget is what makes the whole industry tick, and it is a fact that Coca-Cola have managed to spin into a spectacular marketing ploy that has reached the scale of urban myth. The Wikipedia entry on the subject is entitled 'Coca-Cola formula', not 'recipe,' as though attempting to pick apart its atomic structure. Rosler quotes Elizabeth Candler Graham's *Classic Cooking with Coca-Cola*: 'It is something of a paradox in this age of heightened consumer awareness that millions of Americans blithely drink can upon can and bottle upon bottle of a beverage filled with unidentified ingredients.'[10] Rosler includes this recipe for homemade Coke, found online at tcr.hypermart.net, where the author LaZy claims to have had to fight their way past 500 guards to acquire it:

28ml caffeine
28ml vanilla extract
10ml orangeoil
10ml lemonoil
10ml nutmegoil
10ml cinnamonoil
10ml koreanderoil
10ml nerolioil
224ml alcohol
112ml coca extract
84ml lemonacid
224ml limejuice
13.62kg sugar
9.5l water

Mix the caffeine and the limejuice in 224ml boiling water. Add the vanilla extract, the orangeoil, the lemonoil, the nutmegoil, the cinnamonoil, the koreanderoil, and the nerolioil when the mixture has cooled. Wait acouple of minutes and then add the rest of the ingredients and the water. Let the mixture rest for 24 hours. Should make 10 liters of Coca-Cola.

An array of industrial-scale recipes are then included, each incorporating one or more of coffee, chocolate and Coca-Cola in grotesque quantities:

Brazilian Iced Chocolate Coca-Cola
12 1/2 pounds unsweetened chocolate
25 cups sugar
13 1/2 gallons coffee, double-strength and hot
16 1/2 gallons milk
10 gallons Coca-Cola, chilled
Whipped cream or vanilla
Ice cream
In the top of double-boilers over hot water,
melt chocolate. Stir in sugar. Gradually stir in
hot coffee, mixing thoroughly. Add milk; con-
tinue cooking until all particles of chocolate
are dissolved and mixture is smooth, about
10 minutes.
Pour into jars. Cover and chill. When ready to
serve, stir in chilled Coca-Cola.
Serve over ice cubes in tall glasses, topped with
whipped cream.
If you want to save this for dessert, add a scoop
of vanilla ice cream to each serving. Makes 300
gallons, or 500 servings.[11]

Coffee Punch
6 liters strong, cold coffee
1 liter sugar
10 liters Coca-Cola
10 bottles of dry white wine
Ice
Thin slices of orange
Prepare strong coffee and sweeten with sugar.
Let cool. Place ice cubes in a punch bowl and
pour over cold coffee, cola, and white wine.
Decorate with orange slices. Makes 100 servings.[12]

Mexican Coca-Cola Muffins
50 gallons Coca-Cola, room temperature
1 1/2 tsp. baking powder
9 cups instant coffee
2 cups baking soda
1 gallon unsweetened chocolate cocoa mix
1 cup salt
1 1/2 gallons Kahlua liqueur
5 1/2 gallons pecans, chopped
2 cups vanilla
200 eggs
20 dry gallons plain flour
2 cups butter melted
100 cups sugar
5 gallons buttermilk
Preheat oven to 350°F. Grease muffin pans.
Combine Coca-Cola, instant coffee, and unsweet-
ened chocolate cocoa; whisk to smooth consis-
tency. Mix in Kahlua and vanilla to coffee mixture
and set aside. Sift together flour, baking powder;
baking soda, salt, and sugar. Stir in pecans.
Whisk together eggs, melted butter and butter-

milk. Add to Coca-Cola mixture, blending well.
Make a well in dry ingredients and add liquid,
stirring quickly and lightly. Spoon batter into
greased muffin cups.
Bake about 15 to 20 minutes, or until done. Cool
slightly on wire rack. Remove from pan. Makes
180 to 200 muffins. (I found this recipe in
Cooking with Coca-Cola, a cookbook compiled
for the Third Annual Coca-Cola Days in Atlantic,
Iowa, in 1995.)[13]

Coca-Cola Salad
100 cans Bing cherries
100 cans crushed pineapple (large)
200 large boxes cherry gelatin (Jell-O)
9 1/2 gallons suspicious Coca-Cola
100 cups pecans
50 pounds cream cheese
Boil juices from fruits (plus enough water to make
13 gallons), add Jell-O and stir until dissolved. Add
nuts, cherries (chopped), and drained pineapple.
Add Coca-Cola. Chill until partially set, then add
cream cheese cut into small cubes. Chill overnight.[14]

Cooking with Coca-Cola seems to speak volumes about the
extent to which people have taken this drink into their hearts,
both culturally and physically, and while it remains a speciality
of the US, Nigella Lawson also included a recipe for Coca-Cola
Cake in the top-selling *How to be a Domestic Goddess*. Convenience
foods have freed millions of women from stove-top slavery, but
in reality this 'solution' is exemplary of one of many widening
inequalities. While a packet of four Sainsbury's Belgian chocolate
éclairs costs £1.40, following the recipe for chocolate éclairs in
Raymond Blanc's *Kitchen Secrets* (2011), the cost of ingredients

alone for four éclairs would be approximately £1.27, which does not include gas/electricity, equipment, packaging, purchasing the book (hardback RRP £25) or, most significantly, time. The forgotten cost is that of labour and, more often than not, labour carried out by women.[15] According to Patricia Allen and Carolyn Sachs in the *International Journal of Sociology of Food and Agriculture*: 'Global commodity chains, especially in horticulture, rely on women as disadvantaged workers in processing and packinghouses. Women are preferred workers in vegetable and fruit production, which is seasonal, part-time, and flexible... In the USA, women are the preferred workers in the lower echelons of food processing, where they tend to dominate low-level, high-intensity jobs.'[16] These industries not only shade their ingredients and manufacturing processes from view, but through the diminished power of unions and the erosion of production-based politics, labour is also concealed. As Janet Radcliffe Richards said in her chapter on 'Women's Work': 'How can a particular piece of work be respected, if it is invisible?'[17]

Mika Rottenberg's film installations *Mary's Cherries* (2004) and *Dough* (2005–06) offer a visceral glimpse into such assembly-line environments, albeit strange fantasy versions. In *Mary's Cherries* the factory line runs vertically downwards, with one working woman per small, stacked room. Every room is a snug, constraining fit, made-to-measure for each body. A line of women manufacture maraschino cherries: a woman pedals to create energy to light a blue bulb; under the bulb, Mary's hand is treated with spray in order to grow red nails at speed; one is clipped and dropped through a hole, to a woman who beats and softens it; Rose then moulds and squelches it into a ball and then drops the cherry into a pot. The idea for the piece came in part when the artist learnt of a woman who quit her job and just sold her blood for a living when she discovered she had a very rare blood type. In the use and selling of women's bodies for food manufacture, it is reminiscent of artist Chrissy Conant's project

for which she harvested 12 of her own eggs, packaged and branded them as Chrissy Caviar.[18]

In *Dough*, a similar processing line runs in a cross-shape, where women work with a greyish dough which begins in vast swathes, caused to rise by the pollen-induced tears of one of the workers. The actors in Rottenberg's films are chosen for their unusual or extreme physiques: *Dough* features Queen Racqui who weighs 600lb, and Tall Kat who measures 6'9". Rottenberg chooses women who 'already advertise themselves and rent out their bodies. They are their own managers—they own the means of production.'[19]

Whether empowered or enslaved, the acted roles and name-tabbed uniforms are redolent of low-wage jobs, the kind where workers become estranged from the product they labour to create and may never see it in its totality. In turn, the consumer is estranged from the product, ignorant of its origins or the processes and labour required for its creation. The complexity of *Romances of the Meal* and Mika Rottenberg's films befits a subject which cannot be reduced to didactic stances, but both draw attention to the way food is made and marketed, and to the fact that perhaps we are being pushed away from valuing the things we should by lifestyle aspiration, brand identities and convenience. Immaterial capital is shielded and wielded by the coded ingredients on a packet of Belgian chocolate éclairs, Coca-Cola's secret recipe and Nigella's Chocolate-Coffee Volcano fantasy.

Cheeseboard
Some Cookbooks 1941–2015

1940s

More Kitchen Front Recipes (Ambrose Heath, 1941)

Come Into The Garden, Cook (Constance Spry, 1942)

Wise Eating in Wartime (Ministry of Food, 1943)

Gardening for Good Eating (Helen M Fox, 1943)

ABC of Cookery (Ministry of Food, 1945)

Off the Beeton Track (Peter Pirbright, 1946)

Florence Greenberg's Jewish Cookery Book (Florence Greenberg, 1947)

Cookery and Nutrition (JM Holt, 1947)

Husband-Tested Recipes (Mary Lee Taylor, 1949)

1950s

Health For All (Harry Benjamin, 1950)

Mediterranean Food (Elizabeth David, 1950)

French Country Cooking (Elizabeth David, 1951)

Basic Cookery (Good Housekeeping Institute, 1951)

Jewish Cookery (Leah Wolff Leonard, 1951)

Good English Food – Local and Regional: Famous Food and Drink of yesterday and today Recorded with Recipes by Florence White, Founder of the English Folk Cookery Association (Florence White, 1952)

The Hostess Cookbook (Helen M Cox, 1952)

Dishes Men Like (published by Lea & Perrins Worcestershire Sauce, 1952)

German Cooking (Robin Howe, 1953)

The Reluctant Cook (Ethelind Fearon, 1953)

Indian Cooking (Savitri Chowdhary, 1954)

The Alice B Toklas Cookbook (Alice B Toklas, 1954)
Italian Food (Elizabeth David, 1954)
Summer Cooking (Elizabeth David, 1955)
Food in England (Dorothy Hartley, 1955)
The Home Book of Spanish Cookery (Marina Pereyra de Aznar and Nina Froud, 1956)
The Constance Spry Cookery Book (Constance Spry and Rosemary Hume, 1956)
The Art of Chinese Cooking (Benedictine Sisters of Peking, 1956)
The Omelette Book (Narcissa Chamberlain, 1956)
New Guide To Intelligent Reducing (Gayelord Hauser, 1956)
Cake Making in Pictures (Muriel Downes, 1957)
Plats du Jour, or Foreign Food (Patience Gray and Primrose Boyd, 1957)

1960s
Cookery in Colour (Marguerite Patten, 1960)
The I Hate To Cook Book (Peg Bracken, 1960)
Cooking In A Bedsitter (Katharine Whitehorn, 1960)
French Provincial Cooking (Elizabeth David, 1960)
Larousse Gastronomique: The Encyclopaedia of Food, Wine, and Cookery (Prosper Montagné, 1st English trans., 1961)
To Love and To Nourish: Cookery Book for Brides (Mona Chesterfield, 1964)
First Slice Your Cook Book (Arabella Boxer, 1964)
Jewish Cooking for Pleasure (Molly Lyons Bar-David, 1964)
The Awful Cook's Book (Sonia Allison, 1965)
Let's Throw A Party (Edna F Claughton, 1965)
Oh, for a French Wife! (Ted Moloney and Deke Coleman, 1965)
Cooking For Brides (Ted Moloney and George Molna, 1965)
The Executive Cook Book (Alice Miles, 1965)
Caribbean Cookery (Winifred Grey, 1965)
The Way To Cook (Julia Child, 1965)
Running Your Home: Food and Entertaining, Mills & Boon –

Design For Living series (Anne Allison, 1966)
Adventurous Cooking with Fanny Cradock (Fanny Cradock, 1966)
Adventurous Cook: Recipes from Out Of The Way Places (Beryl Gould-Marks, 1966)
The I Still Hate To Cook Book (Peg Bracken, 1967)
No Time To Cook Book (Hilda Finn, 1967)
Look, You Can Cook! (Rosemary Hemphill, 1967)
A Book of Middle Eastern Food (Claudia Roden, 1968)
Carrier International Cookery Cards (Robert Carrier, 1968)
Zen Macrobiotic Cooking (Michel Abehsera, 1969)
Personal Choice (Zita Alden, 1969)
Cook? Yes She Can (Janet Wier, 1969)

1970s
The Four Seasons Cookery Book (Margaret Costa, 1970)
The Business Woman's Cookbook (Elizabeth Craig, 1970)
Diet for a Small Planet (Frances Moore Lappé, 1971)
The Horoscope Cook Book (Sonia Allison, 1971)
How to Cheat at Cooking (Delia Smith, 1971)
The Professor's Table: The Intelligent Woman's Guide to Good Cooking (Evelyn Adams, 1971)
Wholefood Cookery Book (Ursula M Cavanagh, 1971)
The World In Your Saucepan (Hilda Finn, 1971)
English Food Is Good! (Cliff Jansen, 1971)
Thelma Brown's Silhouette Book of Slimming (Zita Alden, 1972)
Leith's All-Party Cookbook (Prudence Leith, 1972)
Recipes of the Orient (Abbas Ilias Azhar, 1972)
Earth Medicine – Earth Foods (Michael A Weiner, 1972)
Busy Mother's Cook Book (Patsy Kumm, 1972)
Contemporary Meal Management (Mary Kramer and Margaret Spader, 1972)
Not Just A Load of Old Lentils (Rose Elliott, 1972)
Macrobiotic Cooking (Eunice Farmilant, 1972)

Cooking With Flowers (Zack Hanle, 1972)

Mixer and Blender Cookery for the Housewife (Joan Stopford Beale and Katharine Howard, 1972)

Shopping For Your Deep Freeze (Sheila Jones, 1972)

The Complete Galloping Gourmet (Graham Kerr, 1973)

Cooking In A Hurry (Marguerite Patten, 1973)

The Way to a Man's Heart (Sadie Levine, 1973)

Secrets of the Great French Restaurants (Louisette Bertholle ed., 1973)

Fondue and Casserole Cookery (Maggie Black ed., 1973)

Soufflés, Quiches, Mousses and the Random Egg (George Bradshaw, 1973)

The Beautiful People's Diet Book (Luciana Avedon and Jeanne Molli, 1974)

Curries from the Sultan's Kitchen (Doris M Ady, 1974)

The New Carbohydrate Counter (Anne Ager, 1974)

Short Cut Cookery (Mabel Claire, 1974)

Nutrition and Your Mind (George Watson, 1974)

Fondue and Tabletop Cookbook (Marina Wilson, 1974)

The Forget-About-Meat Cookbook (Karen Brooks, 1974)

Blend It Splendid (Stan and Floss Dworkin, 1974)

Family Circle Cookery Cards (Family Circle, 1974)

English Food (Jane Grigson, 1974)

Super Natural Cookery (Jim Corlett, 1974)

Pizza Express Cookbook (1975)

An Invitation to Indian Cooking (Madhur Jaffrey, 1976)

1980s

The Cook Book (Terence and Caroline Conran, 1980)

Microwave Baking (Val Collins, 1980)

Floyd's Food (Keith Floyd, 1981)

The Fabulous Gourmet Food Processor Cookbook (Judy Gethers, 1981)

Fine Art of Garnishing (Jerry Crowley, 1981)

Madhur Jaffrey's Indian Cookery (Madhur Jaffrey, 1982)

Real Flavours: The Handbook of Gourmet and Deli Ingredients (Glynn Christian, 1982)

The Complete Guide to the Art of Modern Cookery (Auguste Escoffier, 1983)

Official Foodie Handbook (Ann Barr and Paul Levy, 1984)

Darling, You Shouldn't Have Gone to So Much Trouble (Caroline Blackwood and Anna Haycraft, 1984)

Visual Delights (Natalie Hambro, 1985)

Honey From a Weed: Fasting and Feasting in Tuscany, Catalonia, the Cyclades and Apulia (Patience Gray, 1986)

One is Fun (Delia Smith, 1986)

Confectionery Design (Lindsay John Bradshaw, 1987)

The Essential Olive Oil Companion (Anne Dolamore, 1988)

At Home with the Roux Brothers (Albert and Michel Roux, 1988)

Recipes from Le Manoir Aux Quat' Saisons (Raymond Blanc, 1988)

English Seafood Cookery (Rick Stein, 1988)

Catalan Cuisine: Europe's Last Great Culinary Secret (Colman Andrews, 1989)

Complete Illustrated Cookery Course (Delia Smith, 1989)

1990s

Delia Smith's Christmas (Delia Smith, 1990)

Cooking for Friends (Raymond Blanc, 1991)

Professional Touches (Lesley Herbert, 1991)

Complete Cookery Course: Classic Edition (Delia Smith, 1992)

Real Fast Food (Nigel Slater, 1992)

Floyd on Spain (Keith Floyd, 1992)

Roast Chicken and Other Stories (Simon Hopkinson with Lindsey Bareham, 1994)

The River Café Cook Book (Rose Gray and Ruth Rogers, 1995)

Culinary Artistry (Andrew Dornenburg and Karen Page, 1996)

Cooking For Blokes (Dr Duncan Anderson and Marian Walls, 1996)

A Year at Ballymaloe Cookery School (Darina Allen, 1997)

Blanc Vite: Fast, Fresh Food from Raymond Blanc (Raymond Blanc, 1998)

How To Eat (Nigella Lawson, 1998)

The Big Red Book of Tomatoes (Lindsey Bareham, 1999)

Sally Clarke's Book: Recipes from a Restaurant, Shop and Bakery (Sally Clarke, 1999)

The Naked Chef (Jamie Oliver, 1999)

Nigella Bites (Nigella Lawson, 1999)

Gary Rhodes' Sweet Dreams (Gary Rhodes, 1999)

Sally Clarke's Book (Sally Clarke, 1999)

Nose To Tail Eating: A Kind of British Cooking (Fergus Henderson, 1999)

2000s

Appetite (Nigel Slater, 2000)

How To Be a Domestic Goddess: Baking and the Art of Comfort Eating (Nigella Lawson, 2000)

Moro: The Cookbook (Sam and Sam Clark, 2001)

Nobu: The Cookbook (Nobuyuki Matsuhisa, 2001)

Happy Days with the Naked Chef (Jamie Oliver, 2001)

Living and Eating (John Pawson and Annie Bell, 2001)

The Eagle Cookbook: Recipes from the Original Gastropub (David Eyre and the Eagle Chefs, 2001)

Simply the Best: The Art of Seasonal Cooking (Tamasin Day-Lewis, 2001)

Taste: A New Way to Cook (Sybil Kapoor, 2003)

The Art of the Tart (Tamasin Day-Lewis 2003)

Le Gavroche Cookbook (Michel Roux Jr, 2003)

Dr Atkins New Diet Revolution (Robert C Atkins, 2003)

The River Cottage Cookbook (Hugh Fearnley-Whittingstall, 2003)

How to Cook Better (Shaun Hill, 2004)

The Handmade Loaf (Dan Lepard, 2004)

Eggs (Michel Roux, 2005)

Jamie's Italy (Jamie Oliver, 2005)

Simple French Cookery (Raymond Blanc, 2005)

Dough: Simple Contemporary Bread (Richard Bertinet, 2005)

Potato (Lyndsay and Patrick Mikanowski, 2005)

A Year in My Kitchen (Skye Gyngell, 2006)

The Food Doctor Everyday Diet Cookbook (Ian Marber, 2006)

Jamie's Dinners: The Essential Family Cookbook (Jamie Oliver, 2006)

The Hairy Bikers' Cookbook (Dave Myers and Si King, 2006)

Delia's Kitchen Garden (Delia Smith, 2007)

The Kitchen Diaries (Nigel Slater, 2007)

YO Sushi: The Japanese Cookbook (Kimiko Barber, 2007)

Eating For England (Nigel Slater, 2007)

Today's Special: A New Take on Bistro Food (Anthony Demetre, 2008)

Ottolenghi: The Cookbook (Yotam Ottolenghi and Sami Tamimi, 2008)

Jamie's Ministry of Food: Anyone Can Learn to Cook in 24 Hours (Jamie Oliver, 2008)

A Table in the Tarn: Living, Eating and Cooking in South-west France (Orlando Murrin, 2008)

Riverford Farm Cook Book (Guy Watson and Jane Baxter, 2008)

The Hummingbird Bakery Cookbook (Tarek Malouf, 2009)

Antonio Carluccio's Simple Cooking (Antonio Carluccio, 2009)

Great British Grub (Brian Turner, 2009)

Mary Berry's Baking Bible (Mary Berry, 2009)

The Fat Duck Cookbook (Heston Blumenthal, 2009)

2010s

Ministry of Food: Thrifty Wartime Ways to Feed Your Family Today (Jane Fearnley-Whittingstall, 2010)

Rose Elliot's New Complete Vegetarian (Rose Elliot, 2010)

Leon: Naturally Fast Food (Henry Dimbleby and John Vincent, 2010)

Heart of the Artichoke and Other Kitchen Journeys (David Tanis, 2010)

The Flavour Thesaurus: Pairings, Recipes and Ideas for the Creative Cook (Niki Segnit, 2010)

Good Things to Eat (Lucas Hollweg, 2011)

Flash Cooking: Fit Fast Flavours for Busy People (Laura Santtini, 2011)

Nigellisima (Nigella Lawson, 2012)

Celebrate (Pippa Middleton, 2012)

15-Minute Meals (Jamie Oliver, 2012)

You're All Invited (Margot Henderson, 2012)

Jerusalem (Yotam Ottolenghi and Sami Tamimi, 2012)

It's All Good: Delicious, Easy Recipes That Will Make You Look Good and Feel Great (Gwyneth Paltrow, 2013)

The Fast Diet Recipe Book: 150 Delicious, Calorie-controlled Meals to Make Your Fasting Days Easy (Mimi Spencer and Dr Sarah Schenker, 2013)

The Handmade Home: Inspirational Craft, Food and Flowers (Cherry Menlove, 2013)

Cooked: A Natural History of Transformation (Michael Pollan, 2013)

Le Pain Quotidien Cookbook (Alain Coumont and Jean-Pierre Gabriel, 2013)

Share: The Cookbook That Celebrates Our Common Humanity (Alison Oakervee, 2013)

Cake Craft Made Easy: Step by step sugarcraft techniques for 16 vintage-inspired cakes (Fiona Pearce, 2013)

Love Bake Nourish: Healthier cakes, bakes and puddings full of fruit and flavour (Amber Rose, 2013)

Everyday Raw Detox (Meredith Baird and Matthew Kenney, 2013)

Mediterranean Paleo Cooking (Diane Sanfilippo, 2014)

Rachel Khoo's Kitchen Notebook (Rachel Khoo, 2015)

Select Ingredients List

Adams, Jillian, 'Crab Apple Jelly', *TEXT, Special Issue: Creative Writing as Research II*, Nigel Krauth and Donna Lee Brien (eds.), October 2012
http://www.textjournal.com.au/speciss/issue15/Adams.pdf

Allen, Patricia and Carolyn Sachs, 'Women and Food Chains: The Gendered Politics of Food', *International Journal of Sociology of Food and Agriculture*, vol.15, no.1, April 2007

Andreyeva, Katya, 'The Future is Always an Idea: Interview with Olga Chernysheva', *n.paradoxa*, vol.14, July 2004, pp.49–54

Another Righteous Transfer! Exploring performance in the LA art scene, 'Barbara T. Smith dialogue, The Box, January 16, 2010', blog post, 19 January 2010
http://anotherrighteoustransfer.wordpress.com/2010/01/19/barbara-t-smith-dialogue-the-box-january-16-2010/#more-238

Artist's Books Online, scanned copy of Alison Knowles' *Journal of the Identical Lunch*
http://www.artistsbooksonline.org/works/joil.xml

Attar, Dena, *Wasting Girls' Time: The History and Politics of Home Economics*, Virago, London, 1990

Austin, JL, *How To Do Things With Words*, Harvard University Press, Cambridge, Mass., 1975

Barrett, Michèle and Bobby Baker (eds.), *Bobby Baker: Redeeming Features of Daily Life*, Routledge, London and New York, 2007

Balducci, Temma, 'Revisiting *Womanhouse*: Welcome to the (Deconstructed) "Dollhouse"', *Woman's Art Journal*, vol.27, no.2, Fall/Winter 2006, pp.17–23

Barthes, Roland, 'Deliberation', in Susan Sontag (ed.) *A Barthes Reader*, Vintage, London, 2000

Barthes, Roland, 'Ornamental Cookery', *Mythologies*, (first published 1957), Hill and Wang, New York, 1983, pp.78–80

Battista, Kathy, *Renegotiating the Body: Feminist Art in 1970s London*, IB Tauris, London and New York, 2013

Bernadac, Marie-Laure, *Annette Messager: Word for Word*, Violette Editions, London, 2006

Blanc, Raymond, *Kitchen Secrets*, Bloomsbury, London, 2011

Bloom, Lynn Z, 'Consuming Prose: The Delectable Rhetoric of Food Writing', *College English*, vol.70, no.4, March 2008, pp.346–62

Bracken, Peg, *The I Hate to Cook Book*, Fawcett Publications, New York, 1960

Brunsdon, Charlotte, 'Feminism, Postfeminism, Martha, Martha and Nigella', *Cinema Journal*, vol.44, no.2, Winter 2005, pp.110–16

Cage, John, 'Experimental Music', in *Silence: Lectures and Writings*, Wesleyan University Press, Middletown, CT, 1961 http://archive.org/stream/silencelecturesw1961cage#page/n9/mode/2up

Calle, Sophie, interview with Whitechapel Gallery Director Iwona Blazwick, on the occasion of the exhibition *Sophie Calle:*

Talking to Strangers, 16 October 2009 – 3 January 2010
http://www.youtube.com/watch?feature=endscreen&v=cRx7nFV
uLwA&NR=1

Colquhoun, Kate, *Taste: The Story of Britain through its Cooking*,
Bloomsbury, London, 2007

Cooke, Rachel, 'Why There's More to Cookbooks Than Recipes',
The Observer, 15 August 2010
http://www.guardian.co.uk/lifeandstyle/2010/aug/15/why-we-
read-cookbooks

David, Elizabeth, *A Book of Mediterranean Food*, Penguin, London,
1955

Department for Environment, Food and Rural Affairs, *Food
Statistics Pocketbook 2012*, York, 2012
http://www.defra.gov.uk/statistics/foodfarm/food/pocketstats/

Dennis, Abigail, 'From Apicius to Gastroporn: Form, Function,
and Ideology in the History of Cookery Books', *Studies in Popular
Culture*, vol.31, no.1, Fall 2008

Farrow, Joanna, *200 Easy Cakes & Bakes*, Hamlyn, London, 2013

Finnegan, William, 'Dignity: Fast-food workers and a new form
of labor activism', *New Yorker*, 15 September 2014.
http://www.newyorker.com/magazine/2014/09/15/dignity-4

Fisher, MFK, *With Bold Knife and Fork*, Vintage, London, 2001

Floyd, Janet and Laurel Forster (eds.), *The Recipe Reader:
Narratives, Contexts, Traditions*, Nebraska Press, Lincoln and
London, 2010

Friedman, Ken, Owen Smith, Lauren Swchyn (eds.), *The Fluxus Performance Workbook*, digital supplement to *Performance Research*, vol.7, no.3, 'On Fluxus', September 2002
http://www.deluxxe.com/beat/fluxusworkbook.pdf

Frye Burnham, Linda, '*High Performance*, Performance Art, and Me', *The Drama Review*, vol.30, no.1, Spring 1986, pp.15–51

Geddes-Brown, Leslie, *A Book for Cooks: 101 Classic Cookbooks*, Merrell, London and New York, 2012

Heaton, Nell, *The Complete Cook*, Faber & Faber, 1947

Hepworth, Stephen (ed.), *Space Cooks*, Space Studios, London, 2002

Heresies: a feminist publication of art & politics, #21 Food is a Feminist Issue, vol.6, no.1, 1987

Higgie, Jennifer, 'Questions & Answers' (interview with Suzanne Lacy), *Frieze*, no.149, September 2012, p.142

High Line website, 'High Line Art Performance: Alison Knowles, Make a Salad', 2012
http://www.thehighline.org/high-line-art-performance-alison-knowles-make-a-salad

Hill, Rosemary, 'Swaying at the Stove', *London Review of Books*, vol.21, no.24, 9 December 1999, pp.38–39

Holzhey, Magdalena et al, *Eating the Universe: Vom Essen in der Kunst*, exhibition catalogue, Kunsthalle Düsseldorf and DuMont Buchverlag, Cologne, 2009

Howells, Thomas (ed.), *Experimental Eating*, Black Dog Publishing, London, 2014

Humble, Nicola, *Culinary Pleasures: Cookbooks and the Transformation of British Food*, Faber and Faber, London, 2005

Hunnewell, Susannah, 'The Art of Fiction No.191: Interview with Harry Mathews', *The Paris Review*, no.180, Spring 2007 http://www.theparisreview.org/interviews/5734/the-art-of-fiction-no-191-harry-mathews

Isaak, Jo Anna, *Feminism & Contemporary Art: The Revolutionary Power of Women's Laughter*, Routledge, London and New York, 1996

Jones, Amelia, '"Presence" in Absentia: Experiencing Performance as Documentation', *Art Journal*, vol.56, no.4, Winter 1997, pp.11–18

Kawamura, Sally, 'Appreciating the Incidental: Mieko Shiomi's Events', *Women & Performance: a journal of feminist theory*, vol.19, no.3, 2009, pp.311–36

Kear, Adrian, 'Cooking Time With Gertrude Stein', *Performance Research: On Cooking*, vol.4, no.1, 1999, pp.44–55

Kelley, Lindsay E, *The Bioart Kitchen: Art, Food, and Ethics*, unpublished PhD dissertation (Chairs: Donna Haraway and Warren Sacte), University of California at Santa Cruz, March 2009

Kerr, Merrily, 'Mika Rottenberg: Long Hair Lover', *Flash Art*, July-September 2007, pp.112–14

Kirshenblatt-Gimblett, Barbara, 'Playing to the Senses: Food as a

Performance Medium', *Performance Research: On Cooking*, vol.4, no.1, 1999, pp.1–30

Klein, Jennie, 'Feeding the Body: The Work of Barbara Smith', *PAJ: A Journal of Performance and Art*, vol.21, no.1, Jan 1999, pp.24–35

Kukil, Karen V (ed.), *The Unabridged Journals of Sylvia Plath 1950–1962*, Anchor Books, New York, 2000

Lawson, Nigella, *How to Be a Domestic Goddess: Baking and the Art of Comfort Cooking*, Chatto & Windus, London, 2000

Lawson, Nigella, *Nigella Bites*, Chatto & Windus, London, 2001

Lebovici, Élisabeth, 'The Collector', in Sophie Duplaix (ed.) *Annette Messager: The Messengers*, exhibition catalogue, Centre Pompidou and Prestel, Munich, Berlin, London, New York, 2007

Leonardi, Susan J, 'Recipes for Reading: Summer Pasta, Lobster à la Riseholme, and Key Lime Pie', *PMLA*, vol.104, no.3, May 1989, pp.340–47

Mammen, Kristin and Christina Paxson, 'Women's Work and Economic Development', *Journal of Economic Perspectives*, vol.14, no.4, Fall 2000, pp.141–64

Mark, Lisa Gabrielle (ed.), *WACK! Art and the Feminist Revolution*, exhibition catalogue, The Museum of Contemporary Art and MIT Press, Los Angeles and Cambridge, Mass. and London, 2007

Mathews, Harry, 'For Prizewinners', in *The Case of the Persevering Maltese: Collected Essays*, Dalkey Archive Press, Champaign, Illinois, 2003, pp.3–20

Mathews, Harry, 'Country Cooking from Central France: Roast Boned Rolled Stuffed Shoulder of Lamb (Farce Double)', *circa* 1980, available online courtesy of Texas State University http://www.english.txstate.edu/cohen_p/postmodern/literature/mathews.html

McCall's magazine (eds.), *McCall's Cook Book*, Random House, New York, 1963

McKenna, Kristine, 'A Private World of Women' (Annette Messager interview), *Los Angeles Times*, 11 June 1995 http://articles.latimes.com/1995-06-11/entertainment/ca-19972_1_annette-messager

McKeon, Michael, *The Secret History of Domesticity: Public, Private, and the Division of Knowledge*, The Johns Hopkins University Press, Baltimore, 2007

Mellow, James R, *Charmed Circle: Gertrude Stein and Company*, Henry Holt and Company, New York, 1974

Miller, Wesley and Nick Ravich (producers), 'Mika Rottenberg and the Amazing Invention Factory', part of *New York Close-Up* series, Art21 Inc., 2013 http://www.youtube.com/watch?v=q5l_s52LnwQ

Molesworth, Helen, 'House Work and Art Work', *October*, no.92, Spring 2000, pp.71–98

Montano, Linda M, *Performance Artists Talking in the Eighties*, University of California Press, Berkeley and Los Angeles, 2000

Moran, Caitlin, 'When Caitlin met Nigella', *The Times Magazine*, 22 December 2012

Motte, Jr., Warren F (ed.), *Oulipo: A Primer of Potential Literature*, University of Nebraska Press, Lincoln, 1986

Negarestani, Reza and Robin Mackay (eds.), *Collapse: Philosophical Research and Development – Culinary Materialism*, vol.VII, Urbanomic, Falmouth, 2011

Oliver, Jamie, 'Letter to My Younger Self' interview, *Big Issue*, no.1031, 17 December 2012

Orr, Gillian, 'Sweet taste of sales success: Why are cookbooks selling better than ever?', *The Independent*, 7 September 2012 http://www.independent.co.uk/life-style/food-and-drink/features /sweet-taste-of-sales-success-why-are-cookbooks-selling-better-than-ever-8113937.html

Patten, Marguerite, *Books for Cooks: A Bibliography of Cookery*, Bowker, London and New York, 1975

Penny, Laurie, 'With Tasers and placards, the women of Egypt are fighting back against sexism', *New Statesman*, 15–21 February 2013

Phelan, Peggy (ed.), *Live Art in LA: Performance in Southern California 1970–1983*, Routledge, Oxford and New York, 2012

Piretto, Gian Piero, 'Tasty and Healthy: Soviet Happiness in One Book', in Marina Balina and Evgeny Dobrenko (eds) *Petrified Utopia: Happiness Soviet Style*, Anthem Press, London, 2009

Queneau, Raymond, *Exercises In Style*, Gaberbocchus Press, London, 1958

Radcliffe Richards, Janet, *The Sceptical Feminist: A Philosophical Enquiry*, Pelican Books, Middlesex, 1982

Randolph, Jeanne, 'Sheila Ayearst: Mincemeat – A Recipe for Disaster', *Psychoanalysis & Synchronized Swimming and other writings on art*, YYZ Books, Toronto, 1991 (first published in *Verge: Sheila Ayearst*, exhibition catalogue, Macdonald Stewart Art Centre, Guelph, Ontario, 1990)

Rao, Tejal, 'Lunch As Performance', *The Atlantic*, 28 January 2011 http://www.theatlantic.com/health/archive/2011/01/lunch-as-performance-the-artistic-side-of-tunafish/70374/

Reid, Brian K, 'The USENET Cookbook: an experiment in electronic publishing', Western Research Laboratory, Palo Alto, California, December 1987 http://www.hpl.hp.com/techreports/Compaq-DEC/WRL-87-7.pdf

Reid, Susan E, 'Happy Housewarming!: Moving into Khrushchev-era Apartments', in Marina Balina and Evgeny Dobrenko (eds.) *Petrified Utopia: Happiness Soviet Style*, Anthem Press, London, 2009

Robinson, Julia, 'The Sculpture of Indeterminacy: Alison Knowles's Beans and Variations', *Art Journal*, vol.63, no.4, Winter 2004, pp.96–115

Rosello, Mireille, *Infiltrating culture: Power and identity in contemporary women's writing*, Manchester University Press, Manchester and New York, 1996

Rosler, Martha, 'Romances of the Meal', in Hans-Ulrich Obrist and Barbara Vanderlinden (eds.), *Laboratorium*, exhibition catalogue, Dumont, Cologne, 2001, pp.249–71

Ross, Kristin, 'French Quotidian', in Lynn Gumpert (ed.) *The Art*

of the Everyday: The Quotidian in Postwar French Culture, Grey Art Gallery, New York, 1997, pp.19–30

Scapp, Ron and Brian Seitz (eds.), *Eating Culture*, State University of New York Press, Albany, 1998

de Silva, Cara (ed.), *In Memory's Kitchen: A Legacy from the Women of Terezín*, Rowman and Littlefield, New York, Toronto, Oxford, 1996

Smith, Stephanie (ed.), *Feast: Radical Hospitality in Contemporary Art*, exhibition catalogue, Smart Museum of Art, University of Chicago, 2013

Stein, Gertrude, *How Writing is Written*, Black Sparrow Press, Santa Barbara, California, 1977

Stein, Gertrude, 'Salad Dressing and An Artichoke', in *Tender Buttons: Objects, Food, Rooms*, 1914, np.
http://www.gutenberg.org/ebooks/15396

Storr, Robert, 'Interview with Robert Storr', in *Annette Messager Faire Parade* (1971–95), Editions de la Ville de Paris, 1995

Storr, Robert, 'Robert Storr in conversation with Olga Chernysheva', in *Acquaintances*, exhibition catalogue, White Space Gallery, London, 2009

Tannahill, Reay, *Food in History*, Penguin, London, 1988

Tate Shots: Make a Salad, video, 2008
http://www.tate.org.uk/context-comment/video/performance-make-salad

Theophano, Janet, *Eat My Words: Reading Women's Lives through the Cookbooks They Wrote*, Palgrave, New York, 2002

Toklas, Alice B, *The Alice B Toklas Cookbook*, first published by Michael Joseph in 1954, this edition Serif, London, 1994

Troy, Maria, 'I Say I Am: Women's Performance Video from the 1970s', *Video Data Bank* http://www.vdb.org/sites/default/files/ISayIAm_VDB_MariaTroy_essay.pdf

Voski Avakian, Arlene and Barbara Haber (eds.), *From Betty Crocker to Feminist Food Studies: Critical Perspectives on Women and Food*, University of Massachusetts Press, Amherst and Boston, 2006

USSR Ministry of the Food Industry, *Book of Tasty and Healthy Foods: Iconic Cookbook of the Soviet Union*, (first Russian edition 1939), trans. e-book, Skypeak Publishing, Sandy, Utah, 2012

Waxman, Barbara Frey, 'Food Memoirs: What They Are, Why They Are Popular, and Why They Belong in the Literature Classroom', *College English*, vol.70, no.4, March 2008, pp.363–83

Wells, Kim, 'I Am Woman, Hear Me Whisk: A Short List of Cookbooks', *Women Writers: A Zine*, December 2004 http://www.womenwriters.net/winter05/hearmewhisk.html

Willan, Anne, *The Cookbook Library: Four Centuries of the Cooks, Writers, and Recipes That Made the Modern Cookbook*, University of California Press, Berkeley, Los Angeles, London, 2012

Winkenweder, Brian, 'The Kitchen as Art Studio: Gender, Performance, and Domestic Aesthetics', in , Mary Jane Jacob and

Michelle Grabner (eds.) *The Studio Reader: On The Space of Artists*, The University of Chicago Press, Chicago and London, 2010

Wright, Carol, *The Liberated Cook's Book*, David & Charles, Newton Abbot, London, North Pomfret, Vancouver, 1975

Yoshimoto, Midori (moderator and ed.) and Alex Pittman (ed.), featuring Alison Knowles, Carolee Schneemann, Sara Seagull, Barbara Moore, 'An evening with Fluxus women: a roundtable discussion' (19 February 2009), *Women & Performance: a journal of feminist theory*, vol.19, no.3, 2009, pp.369–89

de Zegher, Catherine (ed.), *Martha Rosler: Positions in the Life World*, MIT Press, Cambridge, Mass. and London, 1998

Notes

Introductions

1. www.guardian.co.uk on 16/04/13.
2. Kim Wells, 'I Am Woman, Hear Me Whisk: A Short List of Cookbooks', *Women Writers: A Zine*, December 2004. <www.womenwriters.net/winter05/hearmewhisk.html>
3. Laurie Penny, 'With Tasers and placards, the women of Egypt are fighting back against sexism', *New Statesman*, 15–21 February 2013, p.20.
4. For recipes in a cultural context see Janet Floyd and Laurel Forster (eds), *The Recipe Reader: Narratives, Contexts, Traditions*, Nebraska Press, Lincoln and London, 2010; for mention of culinary instruction in performance see Barbara Kirshenblatt-Gimblett, 'Playing to the Senses: Food as a Performance Medium', *Performance Research: On Cooking*, vol.4, no.1, 1999, pp.1–30; for a discussion of 'recipe art' see Lindsay E Kelley, *The Bioart Kitchen: Art, Food, and Ethics*, unpublished PhD dissertation (Chairs: Donna Haraway and Warren Sacte), University of California at Santa Cruz, March 2009. The subject of recipes appears in more general discussions of food-based art, for example *Gastronomica: The Journal of Food and Culture* (2001–13); Stephanie Smith (ed.), *Feast: Radical Hospitality in Contemporary Art* (Smart Museum of Art, University of Chicago, 2013); Thomas Howells (ed.), *Experimental Eating* (Black Dog Publishing, 2014).
5. Brian K Reid, 'The USENET Cookbook: an experiment in electronic publishing', Western Research Laboratory, Palo Alto, California, December 1987, p.i. <www.hpl.hp.com/techreports/Compaq-DEC/WRL-87-7.pdf>
6. Susan J Leonardi, 'Recipes for Reading: Summer Pasta, Lobster à la Riseholme, and Key Lime Pie', *PMLA*, vol.104,

no.3, May 1989, p.347.

7. Barbara Kirshenblatt-Gimblett, 'Playing to the Senses: Food as a Performance Medium', *Performance Research: On Cooking*, vol.4, no.1, 1999, pp.1–2.

8. *Ibid.*, p.2.

9. Harry Mathews, 'For Prizewinners', in *The Case of the Persevering Maltese: Collected Essays*, Dalkey Archive Press, Champaign, Illinois, 2003, p.7.

10. Mathews, Harry, 'Country Cooking from Central France: Roast Boned Rolled Stuffed Shoulder of Lamb (*Farce Double*)', circa 1980, available online courtesy of Texas State University.
 <www.english.txstate.edu/cohen_p/postmodern/literature/mathews.html>

11. Susannah Hunnewell, 'The Art of Fiction No.191: Interview with Harry Mathews', *The Paris Review*, no.180, Spring 2007. http://www.theparisreview.org/interviews/5734/the-art-of-fiction-no-191-harry-mathews

12. Nicola Humble, *Culinary Pleasures: Cookbooks and the Transformation of British Food*, Faber and Faber, London, 2005, p.17.

13. Nell Heaton, *The Complete Cook*, Faber & Faber, 1947.

14. Cara de Silva (ed.), *In Memory's Kitchen: A Legacy from the Women of Terezín*, Rowman and Littlefield, New York, Toronto, Oxford, 1996.

15. Sophie Calle interview with Whitechapel Gallery Director Iwona Blazwick, on the occasion of the exhibition *Sophie Calle: Talking to Strangers*, 16 October 2009 – 3 January 2010. <www.youtube.com/watch?feature=endscreen&v=cRx7nFV uLwA&NR=1>

1. Hors d'oeuvre: The Recipe as Escape

1. Alice B Toklas, *The Alice B Toklas Cookbook*, first published by Michael Joseph in 1954, this edition Serif, London, 1994, p.123.

2. *Ibid.*, p.123.
3. Gertrude Stein, 'Salad Dressing and An Artichoke', *Tender Buttons: Objects, Food, Rooms*, 1914, np. <www.gutenberg.org/ebooks/15396>
4. Toklas, pp.11–12.
5. Toklas, p.xi.
6. Elizabeth David, *A Book of Mediterranean Food*, Penguin, London, 1955, p.xii.
7. Roland Barthes, 'Ornamental Cookery', Mythologies, (first published 1957), Hill and Wang, New York, 1983, p.78.
8. *Ibid.*, p.79.

2. Salad: The Recipe as Event Score

1. Midori Yoshimoto (moderator and ed.) and Alex Pittman (ed.), featuring Alison Knowles, Carolee Schneemann, Sara Seagull, Barbara Moore, 'An evening with Fluxus women: a roundtable discussion' (19 February 2009), *Women & Performance: a journal of feminist theory*, vol.19, no.3, 2009, p.374.
2. Peg Bracken, *The I Hate to Cook Book*, Fawcett Publications, New York, 1960, p.60.
3. *Ibid.*, p.50.
4. John Cage, 'Experimental Music', in Silence: Lectures and Writings, p.12. http://archive.org/stream/silencelecturesw1961cage#page/n9/mode/2up
5. Roland Barthes, 'Deliberation', in *A Barthes Reader* (ed. Susan Sontag), Vintage, London, 2000, p.491.
6. *Tate Shots: Make a Salad*, video, 2008. <www.tate.org.uk/context-comment/video/performance-make-salad>
7. McCall's magazine (eds.), *McCall's Cook Book*, Random House, New York, 1963, p.490.
8. Bracken, p.48.

9. Linda M Montano, *Performance Artists Talking in the Eighties*, University of California Press, Berkeley and Los Angeles, 2000, p.173.
10. High Line website, 'High Line Art Performance: Alison Knowles, Make a Salad', 2012.
 <www.thehighline.org/high-line-art-performance-alison-knowles-make-a-salad>
11. Theodor Adorno, 'Cultural Criticism and Society' (1949), reprinted in *Prisms*, MIT Press: Massachusetts, 1983, p.34.
12. Mieko Shiomi quoted in Sally Kawamura, 'Appreciating the Incidental: Mieko Shiomi's *Events*', *Women & Performance: a journal of feminist theory*, vol.19, no.3, 2009 (interview with the author 23 July 2005), p.313.
13. Tejal Rao, 'Lunch As Performance', The Atlantic, 28 January 2011, np.
 http://www.theatlantic.com/health/archive/2011/01/lunch-as-performance-the-artistic-side-of-tunafish/70374/
14. Yoko Ono quoted in Kawamura, p.323, orig. 'Yoko Ono Instruction Painting' in *Yoko at Indica*, exhibition catalogue, np.

3. Entrée: The Recipe as Mimicry

1. Recipe from *Mon livre de cuisine* (My Cookbook), 1972
2. Marie-Laure Bernadac, 'Artist's Notes', *Annette Messager: Word for Word*, Violette Editions, London, 2006, p.356.
3. Robert Storr, 'Interview with Robert Storr', in *Annette Messager Faire Parade* (1971–95), Editions de la Ville de Paris, 1995, p.78.
4. *Ibid.*, p.68.
5. Bernadac, p.358
6. Annette Messager quoted in Kristine McKenna, 'A Private World of Women' (Annette Messager interview), *Los Angeles Times*, 11 June 1995, np.
 <articles.latimes.com/1995-06-11/entertainment/ca-19972_1_annette-messager>

4. Main course: The Recipe Re-formed

1. Peggy Phelan (ed.), *Live Art in LA: Performance in Southern California 1970–1983*, Routledge, Oxford and New York, 2012.
2. Barbara T Smith, descriptive text which the artist insists is exhibited alongside any documentation of the work.
3. Klein, Jennie, 'Feeding the Body: The Work of Barbara Smith', *PAJ: A Journal of Performance and Art*, vol.21, no.1, Jan 1999, p.30.
4. Peg Bracken, *The I Hate to Cook Book*, Fawcett Publications, New York, 1960, p.11.
5. Janet Radcliffe Richards, *The Sceptical Feminist: A Philosophical Enquiry*, Pelican Books, Middlesex, 1982, p.199.
6. *Ibid.*, p.206.
7. Carol Wright, *The Liberated Cook's Book*, David & Charles, Newton Abbot, London, North Pomfret, Vancouver, 1975, p.37.
8. Mabel Claire, *Bamberger's Cook Book For The Busy Woman*, Greenberg, New York, 1932, pp.18–21.
9. Another Righteous Transfer! Exploring performance in the LA art scene, 'Barbara T. Smith dialogue, The Box, January 16, 2010', blog post, 19 January 2010. <anotherrighteoustransfer.wordpress.com/2010/01/19/barbara-t-smith-dialogue-the-box-january-16-2010/#more-238>
10. Sheila Rowbotham quoted in Laurel Forster, 'Liberating the Recipe: A Study of the Relationship between Food and Feminism in the early 1970s', in Janet Floyd and Laurel Forster (eds.), *The Recipe Reader: Narratives, Contexts, Traditions*, Nebraska Press, Lincoln and London, 2010, p.149.

5. Side dish: The Recipe as Reciprocity

1. Michèle Barrett and Bobby Baker (eds.), *Bobby Baker: Redeeming Features of Daily Life*, Routledge, London and New York, 2007, p.46.

2. *Ibid.*, p.46.
3. Mierle Laderman Ukeles, 'Manifesto for Maintenance Art 1969! Proposal for an Exhibition CARE', in Andrea Philips and Markus Miessen (eds.), *Caring Culture: Art, Architecture and the Politics of Public Health*, Sternberg Press, Berlin, and SKOR Foundation for Art and Public Doman, Amsterdam, 2011, p.140.
4. These projects and many more are explored in Stephanie Smith (ed.), *Feast: Radical Hospitality in Contemporary Art*, exhibition catalogue, Smart Museum of Art, University of Chicago, 2013.
5. Linda M Montano, *Performance Artists Talking in the Eighties*, University of California Press, Berkeley and Los Angeles, 2000, p.179.
6. See for example, Grant H Kester, *The One and the Many: Contemporary Collaborative Art in a Global Context*, Duke University Press, Durham and London, 2011; and Claire Bishop, *Artificial Hells: Participatory Art and the Politics of Spectatorship*, Verso Books, London and New York, 2012
7. Barrett and Baker, p.54.
8. *Ibid.*, p.55.
9. Karen V. Kukil (ed.), *The Unabridged Journals of Sylvia Plath 1950–1962*, Anchor Books, New York, 2000, p.269.
10. Stephen Hepworth (ed.), *Space Cooks*, Space Studios, London, 2002, p.37.

6. First entremet: The Recipe as Criticism

1. Jeanne Randolph, 'Ficto-Facto Acto – Dicta Depiction', *un Magazine*, vol.5, no.1, 2011, p.23.
2. Jeanne Randolph, 'Mincemeat – A Recipe for Disaster', in *Psychoanalysis & Synchronised Swimming: and other writing on art*, YYZ Books, Toronto, 1991, p.109.
3. The interview was conducted by the author, by email, in March 2013.

7. Second entremet: The Recipe as Critique

1. Katya Andreyeva, 'The Future is Always an Idea: Interview with Olga Chernysheva', *n.paradoxa*, vol.14, July 2004, p.52.
2. USSR Ministry of the Food Industry, *Book of Tasty and Healthy Foods: Iconic Cookbook of the Soviet Union*, (first Russian edition 1939), trans. e-book, Skypeak Publishing, Utah, 2012, np.
3. *Ibid.*, p.52.

8. Dessert: The Recipe as Immaterial Capital

1. Nigella Lawson, *How to Be a Domestic Goddess: Baking and the Art of Comfort Cooking*, Chatto & Windus, London, 2000, p.164.
2. *Ibid.*, p.181.
3. Rachel Cooke, 'Why There's More to Cookbooks Than Recipes', The Observer, 15 August 2010, np.
 http://www.guardian.co.uk/lifeandstyle/2010/aug/15/why-we-read-cookbooks
4. Philip Stone, charts editor at *The Bookseller*, quoted in Gillian Orr, 'Sweet taste of sales success: Why are cookbooks selling better than ever?', *The Independent*, 7 September 2012, np.
 http://www.independent.co.uk/life-style/food-and-drink/features/sweet-taste-of-sales-success-why-are-cookbooks-selling-better-than-ever-8113937.html
5. Department for Environment, Food and Rural Affairs, *Food Statistics Pocketbook 2012*, York, 2012, pp.11, 59–60.
 http://www.defra.gov.uk/statistics/foodfarm/food/pocket-stats/
6. Martha Rosler, 'Romances of the Meal', in Hans-Ulrich Obrist and Barbara Vanderlinden (eds.), *Laboratorium*, exhibition catalogue, Dumont, Cologne, 2001, p.249.
7. Jamie Oliver, 'Letter to My Younger Self' interview, *Big Issue*, no.1031, 17 December 2012
8. *Semiotics of the Kitchen* (1975) and *Vital Statistics of a Citizen,*

Simply Obtained (1977) were simultaneously on show in a different venue throughout the *Laboratorium* exhibition.

9. Rosler, p.257.

10. Elizabeth Candler Graham, *Classic Cooking with Coca-Cola*, Hambleton-Hill Publishing, Nashville, Tenn., 1994, p.16; quoted in Rosler, p.259.

11. Rosler, p.260. Referenced as follows:
 Recipe from The Internet Chef On-line!
 (www.ichef.com/ichef-recipes/Beverages/2241.html)
 adapted from *International Cooking with Coca-Cola*, a give-away pamphlet from The Coca-Cola Company, 1981. All quantities, in this as in all subsequent recipes, have been adjusted, with the assistance of the Measurements Units Translation page
 (www.ur.ru/~sg/transl/)

12. Rosler, p.262. Referenced as follows:
 SmellTheCoffee.com
 (www.smellthecoffee.com/cgi-bin/cookbook/cookbook.cgi?display:916637145-12666.txt)

13. Rosler, p.264. Referenced as follows:
 Adapted from The Secret to Happiness Coca-Cola Recipes Page
 (wysiwyg://12/ www.sassman.net/secret/coke_recipes.html).

14. Rosler, p.264. Referenced as follows:
 A version of this is posted at Leslie's Coca-Cola Collecting Page link Coca-Cola Dessert Recipes
 (members.spree.com/sip/priesty64/recipes/desserts.htm.)

15. For an insight into the conditions of McDonald's employees (mostly women) in the US, see William Finnegan, 'Dignity: Fast-food workers and a new form of labor activism', *New Yorker*, 15 September 2014.
 http://www.newyorker.com/magazine/2014/09/15/dignity-4

16. Patricia Allen and Carolyn Sachs, 'Women and Food Chains: The Gendered Politics of Food', *International Journal of*

Sociology of Food and Agriculture, vol.15, no.1, April 2007, pp.6–7.

17. Janet Radcliffe Richards, *The Sceptical Feminist: A Philosophical Enquiry*, Pelican Books, Middlesex, 1982, p.200.
18. See www.chrissycaviar.com.
19. Wesley Miller and Nick Ravich (producers), *Mika Rottenberg and the Amazing Invention Factory*, part of 'New York Close-Up' series, Art21 Inc., 2013
http://www.youtube.com/watch?v=q5l_s52LnwQ

zero
books

Contemporary culture has eliminated both the concept of the public and the figure of the intellectual. Former public spaces – both physical and cultural – are now either derelict or colonized by advertising. A cretinous anti-intellectualism presides, cheerled by expensively educated hacks in the pay of multinational corporations who reassure their bored readers that there is no need to rouse themselves from their interpassive stupor. The informal censorship internalized and propagated by the cultural workers of late capitalism generates a banal conformity that the propaganda chiefs of Stalinism could only ever have dreamt of imposing. Zer0 Books knows that another kind of discourse – intellectual without being academic, popular without being populist – is not only possible: it is already flourishing, in the regions beyond the striplit malls of so-called mass media and the neurotically bureaucratic halls of the academy. Zer0 is committed to the idea of publishing as a making public of the intellectual. It is convinced that in the unthinking, blandly consensual culture in which we live, critical and engaged theoretical reflection is more important than ever before.